Praise for Alice Sink

"Sink has taken her memories and channeled them into five years of research and writing that resulted in her book *The Grit Behind the Miracle*, which chronicles the true story of the Infantile Paralysis Hospital that was built in 54 hours in 1944."
—Jill Doss-Raines, *Lexington Dispatch*

"Throughout the rare glimpses from 1900 to around the early 1950's, Sink stuck to one consistent theme in *Kernersville*. Sink portrayed the sense of community."
—Brandon Keel, *Kernersville News*

"*Boarding House Reach* reminds us of one of the most important truths of life: There are no ordinary people! Every story here is fascinating—and every one importantly belongs to history."
—Fred Chappell

"Community abounds in a colorful new book about the history of North Carolina boarding houses—a traveler's guide to a lost place that was small-town and worldly at the same time."
—Lorraine Ahearn, *Greensboro News & Record*

"A very highly recommended addition for academic and community library collections, *Boarding House Reach* could serve as a template for similar studies for other states."
—*Midwest Book Review*

"*Hidden History of the Piedmont Triad* recounts a number of interesting stories from throughout the Triad—from historic people and places to lesser-known colorful slices of life."
—Jimmy Tomlin, *High Point Enterprise*

"[In *Hidden History of the Piedmont Triad*] Sink writes about Lexington's downtown dime stores. She describes how each counter was like a different department of the store, with a candy counter and comic book section popular with children... and makeup counters that carried old-fashioned items such as Tangee lipstick and Evening in Paris perfume."
—Vikki Broughton Hodges, *Dispatch*

"Did you know that a nightclub in High Point once hosted the likes of Ella Fitzgerald and Duke Ellington? Have you heard the story of Lexington native John Andrew Roman, put to death on circumstantial evidence, of the local World War II fighter plane pilot who flew eighty-two missions to prevent German fighters from attacking

American bombers? These are but three of the many little-known stories found in *Hidden History of the Piedmont Triad*."
—*Arbor Lamplighter*

"[*Hidden History of the Piedmont Triad*] covers people, places and events that have been forgotten."
—Ryan Gay, lifestyles editor, *Kernersville News*

"In *Hidden History of the Piedmont Triad*, author Alice Sink rediscovers the quirky stories of the Piedmont Triad…tying North Carolina into the rest of world history."
—*Our State Magazine*

"Author, professor, and Hilton Head resident Alice E. Sink recently introduced her new nonfiction book, *Hidden History of Hilton Head*, which illustrates the island's history, making it accessible to history buffs and casual readers alike. The island itself stars as the main character, and famous visitors…play supporting roles in Sink's Lowcountry epic."
—Kathy Stewart, *Pink Magazine*

"Grounded heavily in interviews and research, *Hidden History of Hilton Head* is not a strictly chronological or comprehensive history, but rather an eclectic collection of fascinating historical anecdotes, trivia tidbits, and more about Hilton Head Island, South Carolina."
—Midwest Book Review

"*Hidden History of Hilton Head* offers a lively array of historical tidbits and tales, focusing on people, lifeways, believe-it-or-not snippets and beloved local places."
—Amazon.com

"You can tell that I enjoyed *No [Wo]man Is an Island*. I knew from p. 4 or so that I was going to have a good time reading it because it was already obvious that you had a good time writing it. What a happy ride!"
—Fred Chappell

"GOOD READ." (Praise for *No [Wo]man Is an Island*)
—*Guilford Woman Magazine*

"The premise of *No [Wo]man Is an Island* is outstanding! I laughed out loud—even hollered a few times…don't remember doing that since *Raney* and *Walking Across Egypt*. I can see it as a TV sit-com if the PC police wouldn't kill it."
—Carol Branard

HIDDEN HISTORY

of the

WESTERN NORTH CAROLINA MOUNTAINS

ALICE SINK

THE
History
PRESS

Published by The History Press
Charleston, SC 29403
www.historypress.net

Copyright © 2011 by Alice Sink
All rights reserved

All images are courtesy of the Library of Congress.

First published 2011

ISBN 978.1.5402.0504.9

Library of Congress Cataloging-in-Publication Data

Sink, Alice E.
Hidden history of the western North Carolina mountains / Alice Sink.
p. cm.
Includes bibliographical references.
ISBN 978-1-60949-036-2
1. Mountain life--North Carolina--History. 2. Mountains--North Carolina--History. 3.
North Carolina--Social life and customs. 4. North Carolina--History. 5. North Carolina--
History, Local. I. Title.
F262.A16S56 2011
975.6'8--dc22
2010052977

In loving memory: Julia, Wilson and Sid

Contents

CONTENTS

3. Hotels, Lodges, Inns and Assembly Grounds

4. People

5. Education

Contents

Acknowledgements
and Contributors

As always, a big thank-you goes to my husband, Tom, who happily volunteers to chauffer me from place to place in search of hidden-history materials. He now refers to this task as "driving Miss Daisy." His proofreading of my manuscripts is extremely helpful, also.

To Will McKay, my editor at The History Press, who believed I could write this book, and to Katie Parry, my publicist at The History Press, who quickly responds to all my emails, answers my questions and arranges my book signings and presentations. I appreciate all your help and support.

To the High Point University Smith Library staff—David, Mike and Nita—who found and ordered interlibrary loan books for me and advised me on my copyright questions. Your assistance is always valuable.

To Julia Ebel, fellow writer, who graciously shared with me her vast knowledge of the Western North Carolina mountains and especially her friendship with Orville Hicks.

To daughter Corey, who lives and works in Western North Carolina and introduced me firsthand to the mountains, when together we chaperoned five teenage grandchildren on my first (and probably last) camping trip.

To the Library of Congress, for wonderful images and pictures to accompany my text.

To our two canine babies, Bogey and Randi, who napped peacefully at my feet as I wrote this book.

Your support means so much!

Chapter 1

There's No Place Like Home

THE ROCK

Many, many moons ago, Blowing Rock's cliffs were home to two tribes, the Cherokee and the Catawba Indians. The hostility between the two tribes constitutes the legend associated with Blowing Rock, North Carolina.

The myth goes this way:

> *Two star-crossed lovers, one from each tribe, were walking near The Rock when the reddening sky signaled to the brave that he must return to his tribal duty, and the maiden urged him to stay with her. His desperation in choosing between duty and love caused him to leap from the edge of the gorge toward the rocks below, while the maiden beseeched the Great Spirit to bring him back to her. The famous winds of the John's River Gorge blew her lover back into her arms, and this legend about The Blowing Rock is still told today.*

During the Civil War, when husbands left to fight in the war between the north and the south, they sent their wives and children to the safest place they knew—Blowing Rock. When the men returned, they also settled in the village. On March 11, 1889, Blowing Rock received its charter and was incorporated. Uncle Joe Clarke became mayor to the three hundred people living there.

SHACKS, CABINS, MANSIONS

In the North Carolina mountains, homes varied in size from a one-room shack to a mansion. Sometimes, an entire family lived in a small farmhouse in the Appalachian Mountains. They cooked over an open fire and slept on beds pushed against rough walls. Oftentimes, old newspapers or cardboard, tacked to those walls, kept the winter wind from whistling through the logs. When family members opened their one cabin door, they saw the majestic Smoky Mountain range towering above shocks of corn.

If a shack had two rooms, the kitchen and washroom were often combined. Some families were a little more fortunate and had a larger cabin with second-floor sleeping quarters. Occasionally, an Appalachian Mountains home was large enough to house two families. Many farm families also built a freestanding meat house.

Sometimes, when farms provided an insufficient living and other work was not to be found, individuals and families had to move. Such was the case of one man, who left his three-hundred-acre farm in the North Carolina mountains when his parents died. He walked forty-five miles to Chesnee, South Carolina, where he lived as a sharecropper and, subsequently, the grandfather of fifty-six children.

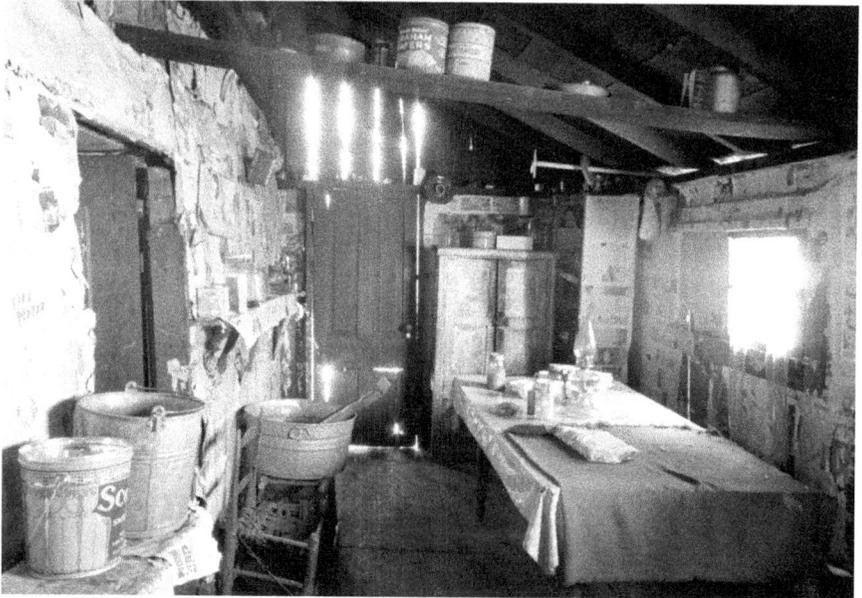

Kitchen and washroom.

There's No Place Like Home

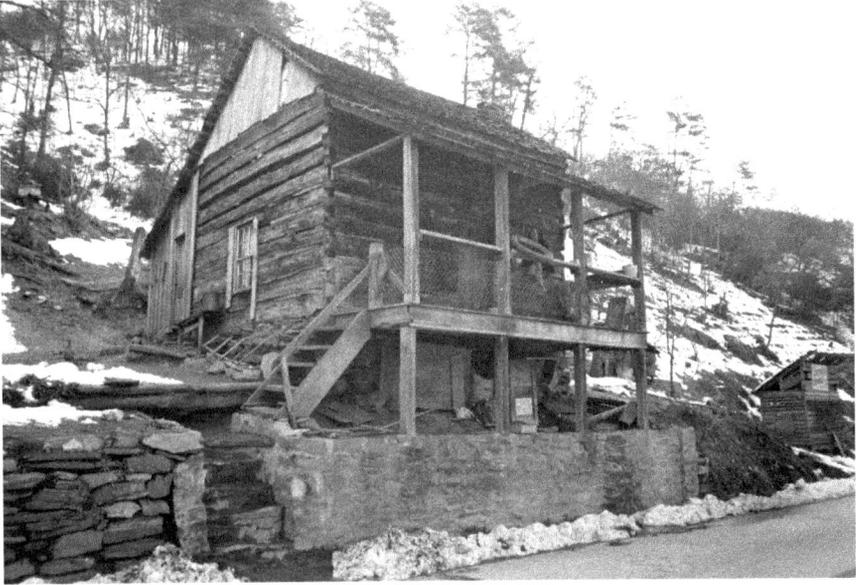

A two-family mountain home.

In an article entitled "Log Cabin Architecture, History and Styles," Jeannie Land explores some misconceptions about log buildings:

> *Log cabins were not the first type of shelter built by all American colonists. The term "log cabin" today is often loosely applied to any type of log house, regardless of its form and the historic context of its setting. "Log cabin" or "log house" often conjures up associations with colonial American history and rough frontier life. While unaltered colonial era buildings in general are rare, historic log buildings as a group are neither as old nor as rare as generally believed. One and two-story log houses were built in towns and settlements across...southern mountain regions; log continued to be a basic building material despite the introduction of wooden balloon frame construction. By the early 20th century, the popularity of "rustic" architecture had revived log construction throughout the country, and in many areas where it had not been used for decades.*

Apparently, photographers took many pictures of mountain cabins during the first half of the twentieth century. Photographic interest seemed to peak between 1914 and 1917. Then, in the 1940s, housing began to take a different form. A Tennessee Valley Authority's (TVA) experimental

trailer house was backed up onto a foundation equipped with wheels on the underside and tracks on the top side. The trailer wheels were rolled onto the tracks and then taken to the desired spot.

Not all homes were primitive; in fact, many were large, luxurious and fashionable. The Henrietta House at 78 Biltmore Street, Asheville, North Carolina, could even be called a mansion. Also, Belvedere, built in 1905 as the estate of the late Captain Thomas D. Johnson, was the residence of Johnson's daughter, Eugenia. Johnson had served as mayor of Asheville in 1869, was later elected to the state House and Senate and, by 1884, was a member of Congress. Built by architect Richard Sharp Smith (who oversaw construction of the Biltmore House), the multigabled two-story frame house featured, according to one report, "European style architecture, including pebbledash wall surfaces, multi-paned windows, half timbering, and a projecting bay window."

The Chestnut Hill Historic District of Ashville, a residential neighborhood with tree-lined streets, had both fine housing purchased by the wealthy but also homes for servants, laborers, businessmen, lawyers and teachers. Chestnut Hill residents included Senator Jeter C. Pritchard, state attorney general Theodore Davidson and Dr. Karl Von Ruck, whose scientific research led to his discovery of a tuberculosis vaccine for the prevention and cure of the disease. Reportedly, Dr. Von Ruck's vaccine cured Senator John W. Kern of Indiana.

Many folks have visited the French Renaissance manor Biltmore House, which is said to be the largest private home in the United States. When few houses in the mountains had bathrooms, Biltmore House boasted forty-three. Impressive also are the sixty-five fireplaces, thirty-four bedrooms, Banquet Hall, huge library and three kitchens. Guests were definitely in awe of the gracious home and surrounding vineyards; however, the estate owners and staff were also impressed with the sometimes-forgotten, November 13, 1902 visit of President Theodore Roosevelt and his party. This event was so important, school children lined the street to greet the nation's chief.

BOARDING HOUSE REACH

By 1910, Asheville, North Carolina, had scores of boarding houses, which held twelve thousand to fifteen thousand people. Rates were reasonable at six dollars to fourteen dollars a week. Ten years later, in 1920, rates had increased from fifteen dollars to twenty-five dollars per week. Prices at the Old Kentucky Home, the boarding house of Thomas Wolfe's mother, were

not that high. Most people know about Mrs. Wolfe's boarding house, the setting for *Look Homeward, Angel*; however, it may be a hidden history just how Old Kentucky Home got its name and how Mrs. Julia Wolfe gained possession of the property. Reports indicate this is what happened:

> *Reverend Thomas M. Myers was a Cambellite preacher from Kentucky who had a strong propensity for alcohol and an unstable mental condition—supposedly having undergone several stays in an institution. In August 1898, Myers purchased a large farm near Asheville and named the farm "Old Kentucky Home" after his home state. He later transferred this name to his Spruce Street house. Myers was portrayed by Wolfe in* Look Homeward, Angel *as "Rev. Wellington Hodge." Under Myer's ownership, the Old Kentucky Home was operated by several proprietors In the summer of 1906, Asheville real estate agent Jack Campbell approached Julia Wolfe with the information that Myers's Spruce Street property was on the market. According to Julia, papers for the purchase were drawn up at the law firm of Bernard and Bernard the following day. Myers requested that the name "Old Kentucky Home" be retained for the boardinghouse. On August 30, 1906, ownership was conveyed to Julia E. Wolfe for $6,500. A down payment of $2,000 was made, with $500 to be paid every six months. Julia took actual possession of the house less than one week after the sale. At first Julia tried to operate the boardinghouse from the family's Woodfin Street home, but after a few months, Julia suffered a severe leg infection and began to sleep at the Old Kentucky Home. She took young Tom with her to the boardinghouse and never left.*

Unlike Julia Wolfe, who reportedly ran her boarding house as a real estate investment, many women opened boarding houses because their husband had died, and they needed to support themselves and their children. Such was the case of a forty-seven-year-old widow, Sallie Johnson, who, with her two sons, moved back to her family farm near Hendersonville, North Carolina. Sallie opened the farmhouse to Floridians who stayed during the summer. Sallie cooked three meals a day, except on Sunday. Guests sat around a huge dining room table. Meals included smoked ham, fried chicken, fresh vegetables, biscuits, home-churned butter, jellies, eggs, grits and more. Everyone was served family style with boarders "reaching" across the table for the last biscuit or chicken leg.

In addition to her regulars, Sallie fed noon meals to German prisoners of war who resided in a camp just down the road during World War II. After the

War Department rescued German sailors from U-boat 352, which sank May 9, 1942, the United States government began setting up a number of branch camps—this particular one in Hendersonville—for POWs. These quarters offered safety and provided "living quarters and rations…equal that of the captor country's" in hopes that the Axis governments would reciprocate by treating American soldiers fairly. The POWs found plenty of good food, respect and comfort at Sallie Johnson's table, after a morning of working in the fields at Johnson Farm. Sallie's broom knew no favorites. Although the guards overseeing the POWs expected to eat first, Sallie guarded the doorway with her broom and made them wait until the prisoners had finished.

Another Western North Carolina entrepreneurial woman, Jane Hicks Gentry, ran a boarding house for tourists who made pilgrimages to Hot Spring's famous mineral pools, with the more than one-hundred-degree mineral water that bubbled along the banks of the French Broad River.

These therapeutic springs reportedly cured gout, rheumatism, dyspepsia, torpid liver, paralysis, neuralgia and other diseases and afflictions. People seeking cures for their health problems had begun visiting the waters as early as 1778, but it took another one hundred years before the Buncombe Turnpike made travel more accessible. By 1837, James Patton had completed his 350-room Warm Springs Hotel. Shortly after that, the railroad brought

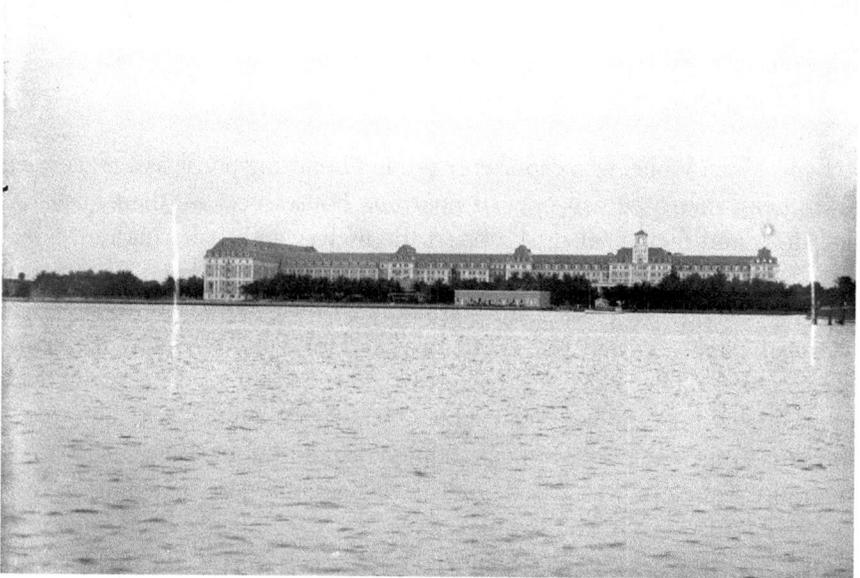

On the French Broad near Hot Springs.

wealthy visitors for extended stays to what was then called Warm Springs, North Carolina (the name changed in 1886) and to the hotel's 16 marble pools, lush lawns and croquet and tennis courts. Those who could not afford the luxuries of the hotel boarded with Jane Gentry. While she cooked, cleaned, farmed, sewed and nursed the ill, Jane told mountain tales and sang ballads. Her stories and songs still survive today. And rumors indicate Grandma Gentry's ghost still roams her old boarding house. When Jane died on May 28, 1925, her daughter, Maud, continued to run the boarding house.

Years later, one of Jane's granddaughters, Bobbie Shuping, visited Maud at the boarding house and experienced a strange incident:

> *Sometime that night, I can't tell you what hour, someone came into the room from the room next to us, walked by the baby crib…checked the baby. The person, silhouetted in the light, walked back by the baby crib and walked out. At that time there was nobody in the house but us and Aunt Maud and Aunt Nola, and they were downstairs. We thought maybe someone had come in for a room in the night and lost their way. In the morning I told Aunt Maud about it. I said, "Someone came in our room during the night." And she said "Oh yes, dear, I understand. That was Grandma Gentry. She always comes and checks the babies who stay in this house."*

So, according to legend, Jane Hicks Gentry continues to care for others, probably singing ballads and telling stories, even to this day.

CATALOOCHEE: FROM HAPPY LITTLE COMMUNITY TO DISPLACEMENT

Cataloochee, located in Western North Carolina in Haywood County, was slow to settle because of Indian attacks, thick forests, underbrush and wildlife. Henry Colwell was not hesitant to claim one hundred acres on Cataloochee Creek in 1814. Obviously, Colwell realized the potential of this mountain land. He began clearing trees for fields and for lumber to build houses and barns.

From 1814 until 1842, more claims were made for land, which early settlers used as base camps for hunting or raising livestock. More families built homes in what was now called Big Cataloochee. From 1854 to 1856, more settlers came to the area and established homes on Coggins Branch; they called their little community Little Cataloochee.

With the population increasing and the existing drovers' road not adequate, in 1825, Haywood County authorized the building of a new toll road. Interestingly, fees for a man and a horse were 18¾ cents; an extra pack horse, 6½ cents; hogs, 1 cent each; and cattle, 2 cents each.

The Cataloochee Turnpike was begun in 1856. The Schoolhouse Patch, the first combination church/school building, was built in 1858. Children in grades one through seven received their education in a one-room schoolhouse. Occasionally, circuit riding preachers arrived in Cataloochee to hold services

According to historical reports, Reconstruction did not greatly affect the people of Cataloochee, who "resumed their pre–Civil War way of life and did well in their wonderful valleys. As a new century came, they still farmed, raising their crops and livestock and performed the chores that maintained their existence. Post Offices, in various citizens' homes and later in the general store, kept them in touch with the outside world."

The true story of Big and Little Cataloochee does not have a happy ending. In 1928, the United States government announced its plans to buy all the land from residents and establish the Great Smoky Mountain National Park.

One report explains the plight of the landowners:

> *The Government did pay them for their land. Most cashed their checks without argument, but a few sued and got a little more money. Regardless of how they felt, they packed up their belongings, said their good-byes and left Cataloochee in tears…Having farmed in the rich fertile soil of Cataloochee, it was disappointing and frustrating to work dried up soil. But, they did the best they could.*

After everyone had moved, the National Park Service took over. Although many of the homes and buildings were burned, some were moved to other parts of the park. Former fields of crops have now become grass fields.

POORHOUSE

The following is a 1904 special report, entitled "Paupers in Almshouses," published by the Department of Commerce and Labor Bureau of the Census:

> *North Carolina. The board of commissioners for each county is authorized to provide for the maintenance and well-ordering of the poor and to employ*

biennially some competent person as overseer of the poor. All persons who become chargeable to any county must be maintained at the county house for the aged and infirm, or at such other place as the board of commissioners may select. Paupers must not be let out at public auction.

The county is not liable for the full support of paupers unless they have a legal settlement in the county, which may be gained by residence for one year. Other paupers or needy persons must be taken care of at the expense of the county to which they belong and be removed thither as soon as practicable.

The county home of the aged and infirm is under the control of the board of commissioners of each county. The board may employ an overseer on a fixed salary to care for the inmates of the home, or may pay a specified sum for the support of the paupers to anyone who will take charge of the home and its inmates.

The county homes are subject to inspection by the state board of public charities. There is also a system of voluntary county visitors to the almhouses.

What had precipitated this 1904 edict? Perhaps events occurring in 1870 and beyond caused the Department of Commerce and Labor to provide

"It Has Been a Hard Winter."

the above specific guidelines. Bill Kincaid of Caldwell County Public Information notes the following:

> *There were always plenty of paupers. Some were able to stay at home or with family, and received a couple dollars a month in support. Those who couldn't stay at home were consigned to the county poor house. In November 1870, the board announced that it would meet at the poor house on Dec. 6 "for the purpose of renting to the highest bidder for two years the lands belonging to said poor house and for the purpose of letting out the paupers of the county for the same length of time to the lowest bidders." A report of the meeting shows one woman was "bid off" by a man "at the sum of $4 per month" and a man was "bid off" by another "at the sum of $2 per month." Remember, though, that money was scarce; the state was still desolate from Civil War; there was no formal welfare program, and Social Security had not been thought about.*

Poorhouses, also called poor farms and almshouses, were known as "outdoor relief." An overseer of the poor, often referred to as a poor master, was an elected official. Needy people could voluntarily ask for admittance to a poorhouse; however, if they were caught begging in public, they were often sent there against their will.

HOME AWAY FROM HOME FOR A LOVE-SICK TRAVELING SALESMAN

In an undated, handwritten six-page letter on Swannanoa-Berkeley Hotel stationary, the letterhead advertised a "European Plan and Running Water or Bath in Every Room." The Swannanoa-Berkeley, just one block from Asheville's Public Square, was managed by W.C. Hawk. One can make an educated guess that the following letter was written after 1905, when the Swannanoa and Berkeley merged.

> *Saturday night*
> *Dearest Friend Ella—*
> *Received your most kind and welcome letter this morning and no words can express how glad I was to receive same. I got up this morning feeling just as blue as it is possible for one to feel and just said to myself if I could only get a letter from you today I would feel lots better and sure enough I*

did. I dreamed about you three times last night (Sat.) and every time I would wake up I was thinking of nothing but you. Sure hate to know that you have been working so hard and only wish I was there to help you if I could. Mr. Schulze has inaugurated a nice place whereby I am going to have some night work also. I received a letter from Mr. Schulze balling me out for not sending in any orders and I am kindly blue myself for I am doing the very best I can.

Ella, I can hardly bear you saying you are going to quit and to think I would hardly ever get to see you. Please do not do this until I see you for I have something to tell you regarding the business and place. Sweetheart, Everette certainly has suffered a very punishment already for the way he drove you last week and guess he has thought about it one million times already so please forgive him cause he certainly has suffered for it. Ella I think the world and all of you and will certainly do my best to treat you right. I know you think I am just one of the average boys but honest I am not and someday you will find that I haven't lied to you. I have told you that I love you and God being my judge I do but still you do not believe me. I know exactly how you feel about all the boys being but repeat again that I am an exception which I consciously believe and do not think I am like the rest of them.

Sure wish you could have been here today and just think how wonderful it would have been, no mystle [sic] or anything to bother us. Ella, Everette sure wants you to stop thinking about leaving and which I know it is going to be hard at first I think it will be easier a little later.

I will not be in until Tuesday afternoon, July 19th and sure want to see you that night as guess they will be wanting me to leave next day. Am trying to mail this so you will get it yourself Tuesday a.m., would appreciate a letter from you very much next Saturday at Taylorsville General Delivery as I expect to spend Sunday there.

With love, as ever. Just yours. Everette

P.S. Will you please deposit $25.00 to my credit at the American Trust Company as I am afraid my acct. is overdrawn. My Bank is in the top drawer of your desk. Thanks. Everette

CHERRY MOUNTAIN

According to one printed report, "The Klan in Western Carolina more closely resembled the Clans of the Highlands—all for one and one for all. The local boys were primed for trouble when a chance visit by Randolph Abbot Shotwell, on behalf of the Order, set them off."

Shotwell, a Rutherfordton business man and newspaper editor, consented to speak to the local boys about making unauthorized night rides. Although not a Klansman, himself, Shotwell said he would see what he could do to explain why the rides must stop.

The site of the meeting would be Cherry Mountain, which was also used for the preannounced gatherings:

For several weeks, in June of each year, there were gatherings at Cherry Mountain. This was due to Amos Owens, a distiller of some reputation, having plenty of Cherry Bounce on hand. Cherry Bounce was an alcoholic beverage distilled at Owen's home-farm. Sometimes as many as 300 people gathered, usually on Thursdays and Saturdays during the cherry season... Shotwell attended the Saturday gathering on June tenth and explained to some of the local men that these unsanctioned rides must not continue... Having done his duty, and having consumed some of the famous beverage he returned to town in merry spirits, satisfied the matter was settled. He was mistaken.

The first person Klan members sought was Judge Logan, whom they knew to be unscrupulous. Next, they visited Judge Logan's son, Bog, [Bob] an attorney, who won cases regularly at Judge Logan's court...although he had never read law or passed the bar. His qualifications were simple; he had a father on the bench...and was editor of the local paper. The third victim on the Klan's list happened to be a fellow Klansman, Jeff Downey, who had been seen hanging around the courthouse and was suspected of being a turncoat. Next came Old "Puky" Biggerstaff, unpopular with the Klan because he had been spreading rumors that members had been persecuting him. Last, the group needed to visit Jim Justice, the county prosecutor, who had called the KKK cowardly skunks...who wouldn't dare come after him.

So, on the stormy night of June 11, 1871, fifty-four men from Cherry Mountain met at Burnt Chimneys about 11:00 p.m. and set out to seek their revenge. They apparently broke into different groups so they could visit each man at the same time. Some headed to Jim Justice's home, broke down his door, pulled him from under his bed where he was hiding and dragged him outside. After one of the men hit him in the head with a pistol, he lost consciousness. When he came to, the Klansmen told him to stop persecuting the Klan; in fact, it would be best if he just dropped out of politics altogether. He swore he would do as they said.

Next, they headed for Biggerstaff and Bob Logan, but both apparently heard them coming and got away. The judge was out of town. The angry group then went directly to Bob Logan's newspaper office. After dumping boxes of type on the floor, they broke a handle off the press and, before leaving, burned copies of past newspaper issues—making torches so they could see better what they were doing. Jeff Downey was caught and promised three hundred lashes, but his whipping was reduced to a few strokes of a pine branch. This, however, intimated Downey, so he quit the Order of the KKK but later testified against Klansmen whenever he had the opportunity.

Payback time was sweet for Jeff Downey, who volunteered to become the star witness for the prosecution.. He took his seat on the witness stand and described the night he was abducted:

> *Disguised men looking more like one would imagine the devil to look then you could ever suppose a human being could fix themselves up to look. Some had disguises and strange fixings on their bodies. The greatest number had only a broad mask over their faces. These were of red and eyes bound with white and the nose white, and horns that stood up ten inches. Some had long white beards. Some had horns which were erect; others had horns which lopped over like mule's ears; and their caps ran up to a point with tassels. One had a red suit out and out; there were a number of stripes on each arm—made of something bright, like silver lace. There was something round, of a circular form, on the breast of one of them, who stood right in front of me.*

The entire episode soon became known as the Cherry Mountain Fiasco, and according to one historian, "national notoriety came to Rutherfordton portraying the town as a hot-bed of KKK enthusiasts."

All in a Day's Work

SORGHUM MILL

Operating a sorghum mill in Western North Carolina proved to be popular, beginning in the 1890s. The history of sorghum was probably introduced to Americans in 1853. Originally a native of Africa, this member of the grass family was welcomed by mountain farmers as a substitute for imported cane sugar. The syrup, which was extracted in a sorghum mill, became an important sweetener for many mountain homes and was used in various recipes. In addition, sorghum flour became the mainstay of many dishes.

GRISTMILL

The term "gristmill" was sometimes also referred to as a "corn mill," or simply any mill that ground grain. The man who ran the mill was called the miller, and he received "a miller's toll" instead of money. When local farmers brought their grain to the mill to be ground into flour or meal, they paid the miller a percentage for his time and machinery. This is how the gristmill operated:

Classical mill designs were usually water powered, through some were powered by the wind or by livestock. In a water mill, a sluice gate was opened to allow water to flow onto or under a water wheel to make it turn. In most water mills, the water wheel was mounted vertically (i.e. edge on) in the water, but in some cases horizontally (the tub wheel and so-called Norse wheel).

In most wheel-driven mills, a large gearwheel called the pit wheel was mounted on the same axle as the water wheel, and this drove a smaller gearwheel—the wallower—on a main driveshaft, running vertically from the bottom to the top of the building. This system of gearing ensured that the main shaft turned faster than the water wheel, which typically rotated at around 10 rpm. The millstones turned at around 120 rpm. The distance between the stones varied to produce the grade of flour required.

The grain is lifted in sacks, which are then emptied into bins, where the grain falls down through a hopper.

The beginnings of apple sauce.

In order to prevent the vibrations of the mill machinery from shaking the building apart, a gristmill would often have at least two separate foundations.

Fortunately, today we don't have to go through this process; we simply purchase a loaf of bread or a sack of corn meal.

BLACKSMITHING

According to one historian, "Long before Western North Carolina was celebrated by visitors for its majestic Blue Ridge Parkway views; even before it was recognized by the ailing for its beneficial climate and therapeutic mountain air, our region was famous for something else: its seemingly-infinite amounts of mineral wealth."

Apparently, Indian tribes did not know how to process iron; Europeans brought that important talent to Western North Carolina. Consequently, it was not long before every community had its own blacksmith shop. Making

tools and weapons from iron proved to be a great advantage to pioneers. Those people who lived in extremely remote areas did not have a local blacksmith shop. Because travel was so time consuming, farmers taught themselves the trade, as explained in one report:

> Out of necessity, these remote, independent farmers learned the trade themselves, often using their own anvil and forge to make and repair tools and household items, objects produced included shoes for mules, oxen and horses; farming tools like plows, rakes, and hoes; guns and traps for hunters; and general use items like axes, hammers, nails, pots, pans, utensils, and knives. One example of the value of the village smith occurred during the Civil War. When a Watauga County blacksmith was drafted for military service, his community petitioned Governor Zeb Vance to reassign him and allow his return so that "farming and other work could continue."

An interesting hidden history tidbit here reveals that Daniel Boone was a blacksmith. Mountain blacksmithing continues with demonstrations at various festivals and today remains a vital part of mountain heritage.

IF QUILTS COULD TALK, OH WHAT THEY COULD TELL!

According to the Alliance for American Quilts, "Quilts tell stories; they illustrate history; they express love and sorrow; they link generations together; they are community; people gather to make them and experience them; they are art; they teach. Quilts matter!"

Probably no one would dare argue that quilting is not an art form. The patterns, colors and borders speak of love.

Using any material they chose—usually scraps from discarded garments, which always brought forth cherished memories, and cloth feed sacks with pretty designs—women not only created a lovely and useful coverlet or wall hanging, they provided themselves with a relaxing break from back-breaking farm chores and, oftentimes, the opportunity to visit with other mountain women.

According to one historian:

> An active quilt frame was the perfect vehicle for social exchange. In such gatherings, it was common to hear singing, chatting, even spirited arguments

about various topics—all while many hands were humming together in cooperative harmony. These quilting bees were important events bringing together community women to accomplish a goal while enjoying interaction and each others' company.

This folk custom perpetuated by Appalachia quilters make the quilting bee even more fun:

The "Cat on the Quilt" was practiced by Appalachian quilters. They placed a cat on a quilt which was being made for a bride's wedding chest. After being placed in the center of the quilt, the cat was tossed into the air. The old folk belief was that the person nearest to where the cat landed would be the next to marry.

Whether it was a lively group activity for women or a solitary respite from a day of chores, quilting has definitely survived.

MAKING MOONSHINE: THE WRONG SIDE OF THE LAW

According to one moonshine article, "There has to be a good reason to go to all the trouble of making moonshine. Actually, there have been several reasons, but they all boil down to one thing: government control of the alcohol trade." Let's review the facts. The United State government had to find some way to pay for the very expensive Revolutionary War. The solution was to put a federal tax on spirits and liquor. Apparently, many citizens were not pleased with this tax, so they kept on doing what they had been doing—making their own whiskey—ignoring the federal tax.

One moonshine article gave the reason:

For these early moonshiners, making and selling alcohol wasn't a hobby or a way to make extra cash; it was how they survived. Farmers could survive a bad year by turning their corn into profitable whisky, and the extra income made a harsh frontier existence almost bearable. To them, paying the tax meant they wouldn't be able to feed their families. Federal agents, called Revenuers, were attacked when they came around to collect the tax, and several were tarred and feathered.

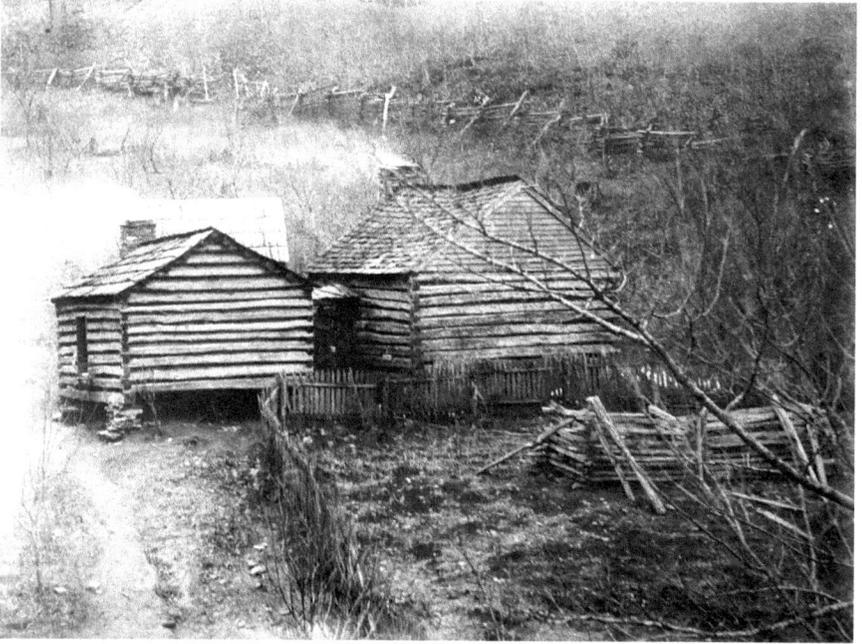

Home of a moonshiner.

Moving right along to the 1860s, when the government tried to collect taxes to support the Civil War, moonshiners were joined by Ku Klux Klansmen; battles became rougher and more brutal, and they fiercely protected the hidden stills. By the 1920s, when Prohibition went into effect, moonshiners were ecstatic. With no legal whiskey available, stills operated in record numbers, and speak-easies, with passwords whispered at hidden doors, sprung up in practically every area.

When Prohibition was repealed in 1933, people had little reason to seek illegal whiskey, although it is reported that some still liked the temptation of trying something forbidden and "flouting government authority." Even today, the Moonshiner's Reunion and Mountain Music Festival remains one of the Appalachian region's most authentic annual folk celebrations.

PUTTING FOOD BY

Preserving a season's bounty of vegetables has been mastered by farmers, mothers and wives of Western North Carolina. The name given to canning excess garden products is called "putting food by," and area canneries

provided safe and time-effective methods of preserving beans, corn, tomatoes and many other vegetables.

Public canneries were founded during World War II. While men were away, serving in the armed forces, women harvested their crops, cooked what they needed at the time to feed their families and then went to a community cannery to "can" the remainder of the crop, to ensure food for the harsh winter months to come. Summer gardens produced huge harvests; in fact, an old southern joke goes like this: "The only reason to lock your car doors in the summer is to keep your neighbors from dumping bags of zucchini in the back seat."

"Canning" was the perfect solution to save the bounty, and the local cannery provided both equipment and fellowship, as described by one observer:

> *The cannery boasts a hard-working kitchen with sizable sinks for washing vegetables, long stainless steel prep counters, kettles the size of kilns (each holds 96 quarts), two cold-water-bath containers, large paddles and plenty of informative, colorful posters. An oil boiler provides the steam that processes everything: vegetables, fruits, meats, stews, soups, juices, sauces, pickles and relishes, and all manner of butters, including apple, pear and pumpkin.*

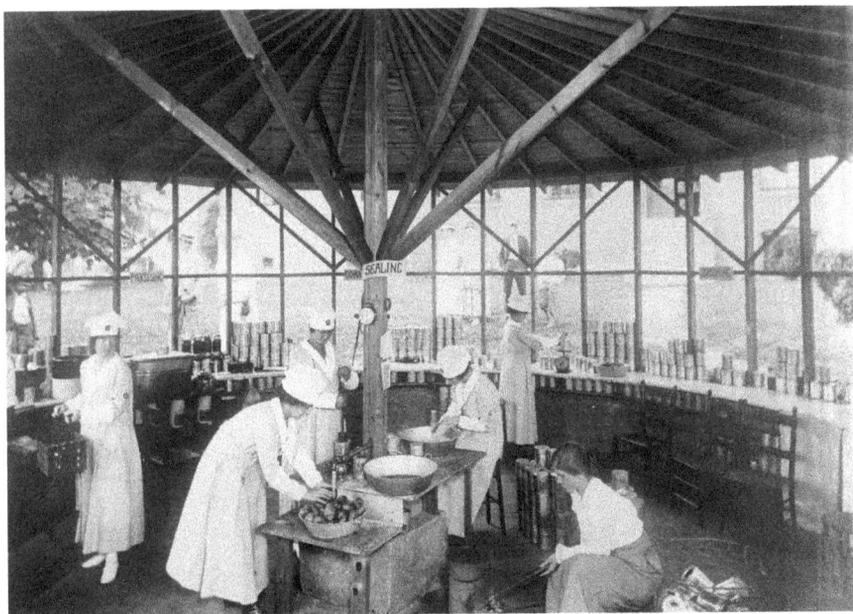

A scene at the community cannery.

Cannery work is loud, physical and hot, as both the volume of conversation and the steam rise when 20 to 30 people crowd into the small space. While all are responsible for their own canning, everyone tends to pitch in and work together. It's an unspoken rule that when you finish your vegetables, you help the next person. That way, it all gets done in a day. If you're fortunate enough to can alongside some of the old timers, they'll pass along advice, best practices and maybe even a shortcut learned through the years. If you're really lucky, they might share a recipe or two.

STAGING

Driving a stagecoach was known as staging. Accompanying the driver, a man known as a shotgun messenger rode as a guard armed with a coach gun. He was responsible for passengers getting safely from one point to another. Travelers rode three abreast, squeezed into a space of fifteen inches each; the ride was not pleasant, as noted by one historical report:

Back and middle rows, both faced forward, and a forward row, faced rearward. Those in the forward and middle rows had to ride with their knees dovetailed. On the center seat passengers had only a leather strap to

A stage in the '30s.

support their backs on a long journey. Passengers rode with baggage on their laps and sometimes mail pouches beneath their feet. Some travelers suffered from motion sickness due to the motion of the coaches, aggravated when the coach traveled over a section of rough road, adding the torment of bouncing on the hard seat, against the roof, or against the side of the coach.

Drivers often continued on their journey for more than twenty days and nights. They made short stops at way stations to change horses. Sometimes the driver made passengers walk when the teams needed to rest or the terrain was hilly, muddy or sandy. Conscientious drivers also had the responsibility to uphold the following rules:

**Abstinence from liquor is requested, but if you must drink, share the bottle. To do otherwise makes you appear selfish and un-neighborly.*

**If ladies are present, gentlemen are urged to forego smoking cigars and pipes as the odor of same is repugnant to the gentler sex. Chewing tobacco is permitted, but spit with the wind, not against it.*

**Gentlemen must refrain from the use of rough language in the presence of ladies and children.*

Homeward bound
from vacation.

Buffalo robes are provided for your comfort in cold weather. Hogging robes will not be tolerated and the offender will be made to ride with the driver.

Don't snore loudly while sleeping or use your fellow passenger's shoulder for a pillow; he or she may not understand and friction may result.

Firearms may be kept on your person for use in emergencies. Do not fire them for pleasure or shoot at wild animals as the sound riles the horses.

In the event of runaway horses remain calm. Leaping from the coach in panic will leave you injured, at the mercy of the elements, hostile Indians and hungry coyotes.

Forbidden topics of conversation are: stagecoach robberies and Indian uprisings.

Gents guilty of unchivalrous [sic] behavior toward lady passengers will be put off the stage. It's a long walk back. A word to the wise is sufficient.

CIVILIAN CONSERVATION CORPS

According to historical documents, in 1933, President Franklin D. Roosevelt set into motion the Emergency Conservation Work (EWC) Act, known more commonly today as the Civilian Conservation Corps, and "with this action, he brought together two wasted resources: young men and land." This move has been called a "peacetime army marching into battle against destruction and erosion of natural resources."

The mountains of Western North Carolina, especially early construction of the Blue Ridge Parkway, profited greatly from the work of the CCC. Various reports indicate that there were no models or rules to go by since the concept of the CCC was new, but that did not slow any of the projects.

This is what happened:

The Army mobilized the nation's transportation system and moved thousand of enrollees from induction centers to working camps. It used regular and reserve officers, together with regulars of the Coast Guard, Marine Corps and Navy to temporarily command companies. The Departments of Agriculture and Interior were responsible for planning and organizing work to be performed. The Department of Labor was responsible for the selection and enrollment through state and local relief offices. Young men flocked to enroll. The enrollees were working hard, eating heartily and gaining weight, while they improved acres of land.

Interestingly, records denoting sociological impacts on the young men are scarce; however, one study does survive that indicates many of the men did not return to their home states, but remained in the mountains. Some, who left after their work was finished, returned with their wives and families to establish new roots in the place "that had renewed and restored self confidence in themselves and in their country."

BUCKET BRIGADE

Perhaps one of the most essential forms of work in the mountains was the manual labor involved in putting out fires. Towns and villages had no public water works or fire departments, so when a fire sprang up, volunteers gathered quickly to organize what was called "a bucket brigade." Dipping water from local springs into many oaken buckets, neighbors formed a long line, passing buckets from the people nearest the spring to the ones closest to the fire.

When communities dug public wells and individuals had private wells, volunteers changed from the fire bucket brigade to "hook and ladder" and "hose-reel" methods of extinguishing fires. The realistic melodrama—"The Ladder of Life"—became a grand spectacular production in New York City and entertained audiences with firefighting methods.

As villages grew into towns and cities, waterworks with reservoirs and pipe lines emerged.

Chapter 3
Hotels, Lodges, Inns and Assembly Grounds

Weaverville

In the 1800s, Weaverville was home to grand hotels, such as the Dula Springs Hotel and Blackberry Lodge. Guests flocked to Weaverville's natural beauty, healthful climate and nearby Asheville's cultural attractions.

A native, Rex Howland, built a trolley line to enable guests to travel the six miles from Asheville. The cost of the trip was a mere thirty-five cents; however, it took the trolley forty-five minutes to go those six miles. When the trolley line stopped running, the town's fine resort reputation had already been established.

Guests probably walked to Weaverville Methodist Church, its rich history dating to 1805, with generations after that rebuilding several times. In 1920, Louise Moore donated a stained glass window depicting the *Good Shepherd* and made of Tiffany glass.

A hidden history tidbit concerning Weaverville might be that author O. Henry stayed in a hotel there, attempting to regain his health "before returning to New York City and squandering it again."

Little Switzerland

The scenic communities of Sapphire, Lake Toxaway, Cashiers, Glenville and Highlands were called Little Switzerland. Guests soon discovered why the area got this name. Hiking was always a great experience. The Whitewater

Hotels, Lodges, Inns and Assembly Grounds

The depot at Weaverville.

The view from the lodge on Mount Toxaway, Sapphire.

Falls, the highest waterfall east of the Rockies, drops 411 feet. Anglers found there some of the best fly-fishing in the United States. Mining for gemstones was popular; in fact, Sapphire received its name because of the numerous sapphires found in the area in the 1800s.

Lake Toxaway, obviously, was "the place to be" in the early 1900s. Here, the first man-made lake of any size was constructed. It measured three miles long and one mile wide, offering fifteen miles of shoreline. Then came construction of the Toxaway Inn, the epitome of elegance and grace. Guests included Henry Ford, Harvey Firestone, Thomas Edison, R.J. Reynolds and George Vanderbilt. Boating, fishing, golf, horseback riding, billiards, swimming, hunting, boating and tennis entertained guests during the day. At night, they enjoyed first-class cuisine, service and dancing to tunes played by well-known orchestras. The walls of Toxaway Inn exhibited art work from the finest galleries of the era. There was never a dull moment—that is, until a hurricane came ashore and headed toward Western North Carolina. The gaiety ended: "On August 14, 1916, the Lake Toxaway dam could no longer

Lake Fairfield and Inn, Sapphire.

hold the perpetual swelling of the lake and the dam gave way, sending 640 acres of water down the Toxaway Gorge. The Toxaway Inn shut down, lay dormant, and eventually was torn down in 1948."

Cashiers was settled by Colonel John A. Zachary and his son in the fall of 1832. They erected cabins, becoming the first homesteaders. The James McKinney family arrived in 1834, bought six hundred acres and kept horses and cows. When fall arrived, the Zachary family moved their livestock to South Carolina for a warmer climate. It is believed that particular tradition contributed to the naming of the village.

There have been many stories as to how Cashiers received its name, but the most popular one is the story of James McKinney's horse, a white stallion for which he had paid quite a handsome sum. He named it "Cash." Fall was approaching, and it was time to herd the horses and cattle south for the winter. Cash was nowhere to be found, so they made the trip south without him. The following spring, the stallion showed up as healthy as, well, a horse. Apparently he had wandered south and found a good feeding place in the valley.

SOUTHERN ASSEMBLY GROUNDS

The idea for Lake Junaluska United Methodist Assembly was conceived in 1908. A group called the Laymen's Missionary Conference believed that a center would benefit the Methodist Episcopal Church, South, "for the purposes of Christian culture and the dissemination of the principles of Christian religion throughout the world." Waynesville was selected because it was already known as a beautiful summer resort area, accessible to many. Incorporated on June 30, 1910, the Southern Assembly began purchasing land, and the site of the assembly was farmland next to Richland Creek, later dammed to make the lake.

Hotel site of Southern Assembly Ground.

KENILWORTH INN

The Kenilworth Inn, a fashionable hotel patronized by northern tourists during the winter and a meeting place for southern conventions during the summer, burned to the ground at two o'clock on the morning of April 14, 1909.

Seventy-five guests, wearing anything they could find quickly, scrambled for the exits. Everyone was accounted for outside the inn. Some of the women "appeared in ball gowns and others in even more scanty raiment and in varying degrees of negligence. Many of the men wore nothing but their underclothing covered by their overcoats. Almost every describable manner of dress was represented."

The *Grand Forks Daily Herald* newspaper gave the following report:

> The fire started in the north end of the building over the boiler room. A strong wind was blowing from the southwest and the flames were quickly fanned to the other end of the frame structure, where the majority of the guests were asleep. Before the fire had been first discovered by two negro boys who were returning from Biltmore, the Vanderbilt place, which is but a short distance from the inn, it had gained good headway and was even then beyond human control. Mrs. A.B. Martin, the hostess, gave first thought to the safety of the guests when she was awakened, and in a short time the alarm had been given in every occupied room in the doomed building.
>
> Many persons after conquering the first thought of self-preservation that had led to instant and precipitate flight, ventured back into the smoke-filled halls and into their rooms to rescue their trunks and other personal effects which they had abandoned. Some brought forth rocking chairs, wash stands and every manner of articles, which soon littered the lawns. As the fire kept raging, fanned by the rapidly increasing wind, the heat became so intense that all hope of saving the possessions was abandoned. Several persons who had re-entered the hostel, not realizing that the fire had reached the south wing, were almost caught. Shouts of friends from the outside were answered by yells for help and heroic efforts of several guests and policemen alone saved the venturesome ones from being cut off from every avenue of escape.

The hotel appeared to be doomed before the Asheville Fire Department got to the scene; however, they were able to save adjoining houses, preventing the flames from spreading by the wind carrying sparks to other roofs. The hotel was destroyed. The loss was estimated at $250,000, with insurance

The Swannanoa near Kenilworth.

placed at $75,000. Several firemen were burned. Former state senator Gazzam of Philadelphia, owner of the inn, jumped from his third floor window and barely missed hitting a stone arch at the front of the inn. He suffered a concussion and broken bones.

GROVE PARK INN

The inspiration for building the grand Grove Park Inn came about in the late 1800s when Edwin W. Grove found Asheville the perfect place to restore his health. He suffered from acute bronchitis, so summer in the mountains relaxed him and made him feel better. Edwin Grove, who was the founder of Grove's Pharmacy and Paris Medical Company in St. Louis, had patents for many over-the-counter medicines.

Grove's inspiration for building the Grove Park Inn came from inspiration he received from Old Faithful Inn in Yellowstone National Park. Desiring

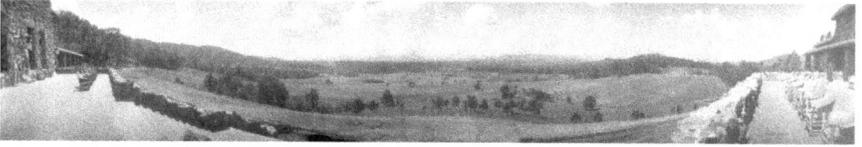

Overlooking the golf links at Grove Park Inn.

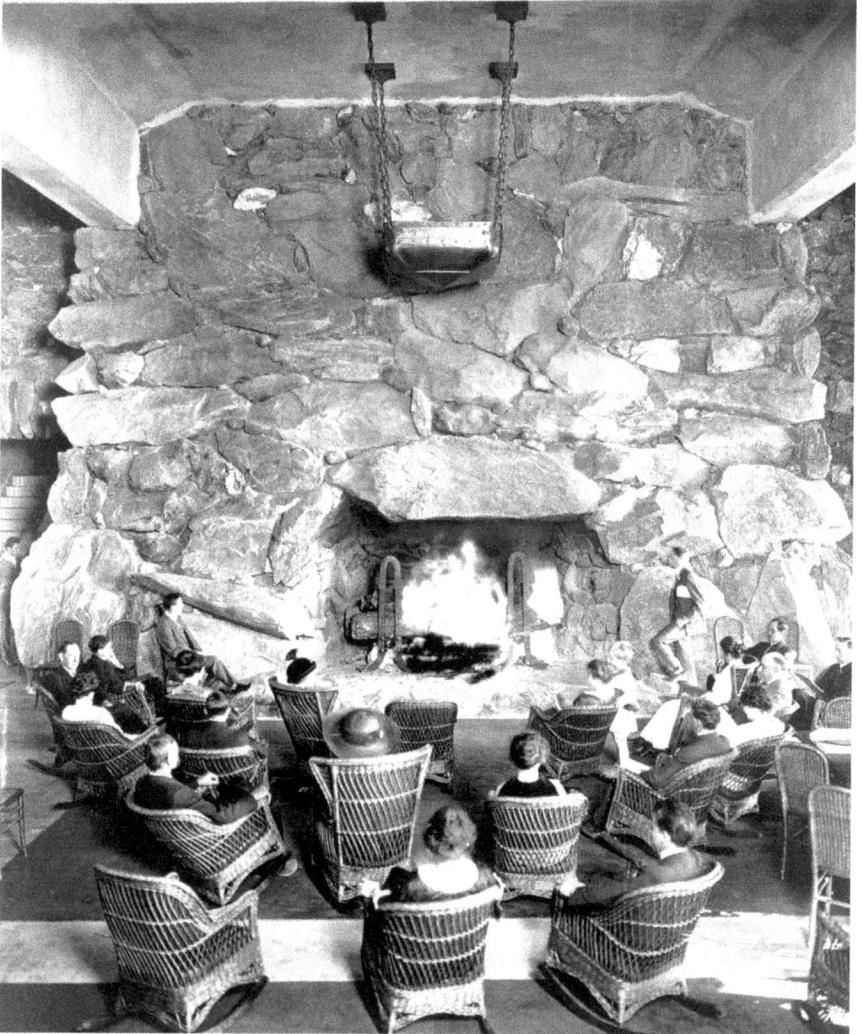

A Grove Park Inn fireplace.

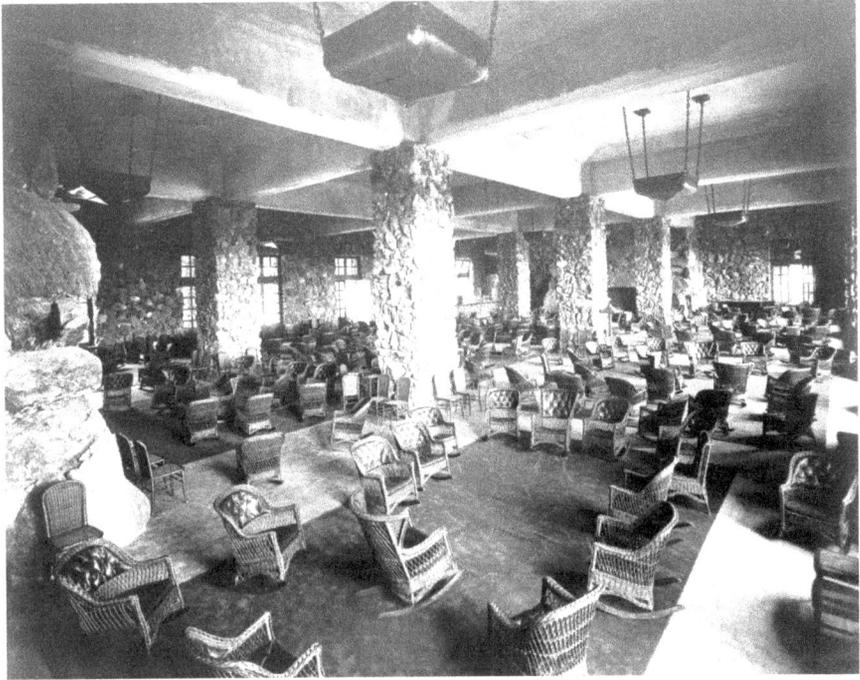

A big room at Grove Park Inn.

the same craggy, rustic style but unable to find an architect who understood what he had in mind, Grove employed his son-in-law, Fred Seely, to design and supervise the construction of the inn in this manner: "Huge granite boulders—some of them weighing as much as 10,000 pounds—were taken from the nearby Sunset Mountain and fitted into place over a steel and concrete frame by Italian stonemasons and hundreds of local workers."

The Grove Park Inn opened on July 13, 1913. Williams Jennings Bryan delivered the opening banquet address. Originally, the lobby contained comfortable pieces. A Roycroft grandfather clock stood against the Great Hall's center column, and another kept time not far away. Yes, the Grove still has two of the three Roycroft grandfather clocks ever manufactured! Engraved on the stone walls of the Great Hall are quotes from Thoreau and Emerson. The Rogues Gallery of the Inn features photographs of famous guests from the 1920s, including Calvin Coolidge, Henry Ford, Thomas Edison and Will Rogers.

Upstairs, rooms 441 and 443 were occupied by F. Scott Fitzgerald, where he lived and wrote in 1935 and 1936. Interestingly, room 441 looks today

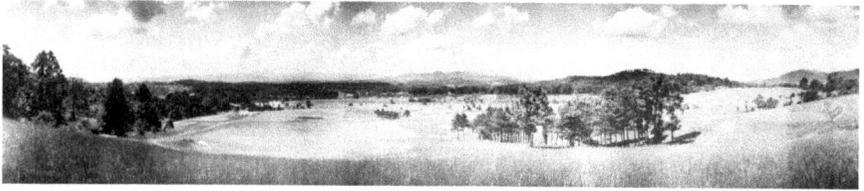

An eighteen-hole golf course.

just the same as when Fitzgerald lived there—"spare and simple Arts and Crafts furniture, no art work on the walls, a simple cotton spread on the bed, a 1920s black dial phone and a writing desk with ink stains in the ink well."

Early on, the food at the Grove Park Inn earned a fine reputation for serving delightful meals.

PRINCESS ANNE HOTEL

In 1922, Anne O'Connell, a registered nurse, built the Princess Anne Hotel in the Chestnut Hill neighborhood of Asheville. Because Asheville was famous for being the best place to treat tuberculosis, O'Connell built near the home of Dr. Karl Von Ruck, a world-renowned tuberculosis specialist. The hotel, which advertised "Comfort First," provided accommodations for family members of patients being treated at O'Connell's tuberculosis sanatorium on Baird Street. According to one longtime resident, "O'Connell was remembered as having long red hair and her head was set on her shoulders perfectly beautifully, and her patients called her Princess Anne."

In 1929, O'Connell sold the hotel, and by 1945, it had become an annex to Appalachian Hall Psychiatric Hospital, and subsequent owners converted it back to a hotel or boarding house. Obviously, O'Connell's "Comfort First" philosophy endured for all guests.

During its years as a boarding house, the hotel was advertised for its "gracious living" for senior citizens, wholesome well-balanced meals" with "beds that refresh, food that pleases." Every room featured a private bath and phone. One of the hotel's most notable residents was activist Florence Ryan, who spent most of her life committed to voter education and registration and fighting for women's equality.

ROUND KNOB HOTEL AT ANDREW'S GEYSER, OLD FORT

A resort hotel, a tall monument and a man-made geyser in Old Fort, at the base of the Blue Ridge mountains, were three sights earlier travelers looked for. Finding these signaled they were in the right area to start their long train ride to Asheville.

The resort hotel, the Round Knob, was built in 1879 in Old Fort to accommodate guests. From sparse descriptions, the hotel obviously was not unlike others in Western North Carolina. What was unique, however, and what drew travelers to the hotel was Andrew's Geyser, created to commemorate those who died while building the difficult run to Swannanoa.

In the late 1900s, the area's railroad, owned by Southern Railways, didn't go farther west than Old Fort. Passengers and cargo going farther than Old Fort had to be hauled by horse to Asheville and points west. Colonel A.B. Andrews, an engineer and then a vice-president for Southern Railways, successfully lobbied the state legislature to authorize money and, more importantly, prison labor to help push the railroad to the Swannanoa Gap, now known as Ridgecrest. The treacherous terrain required twelve miles of track to be built to traverse the three miles of distance, including seven tunnels. During the construction, more than 120 lives were lost to cave-ins, a cholera outbreak and the use of a new explosive, nitroglycerin.

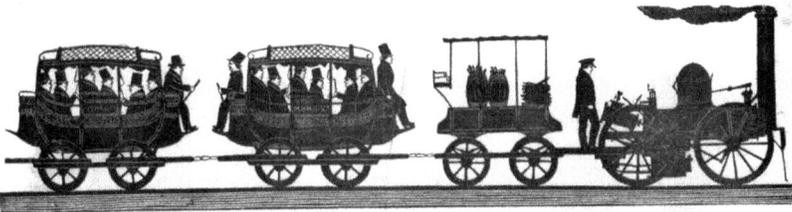

A passenger train.

So, all was well for a while, but then the Round Knob burned in 1903 as a result of a hot ember from one of the trains, something had to be done to keep the tourist trade. This is what happened, according to historical reports:

The "Fathers of Old Fort" didn't want to lose the hotel and the geyser, so in 1911 a wealthy friend of Col A. B. Andrews, an engineer and vice president for Southern Railways, came to the town's rescue. He bought the land around it, moved it across the creek, redesigned it and named it in honor of Andrews. The geyser still stand and sprays today, powered by the dam and the lake on that secluded 7 acres of land, totally surrounded by the protected lands of the Pisgah National Forest. The geyser shoots up over 80 feet high at times. Its water supply is drawn from the Mill Creek.

The Old Fort Arrowhead Monument, a hand-chiseled granite tribute to honor the peace achieved between the Native Americans and the settlers, was erected in 1930. An interesting hidden history is the fact that "at the unveiling, over 6,000 people attended, including chiefs from both the Catawba and Cherokee tribes. These two tribes had never smoked a pipe of peace together until that day."

Old Fort has several other hidden historical claims to fame. The very first trail to Ridgecrest from Old Fort was called the "Suwali" trail and possibly was used by the Cherokee Indians "thousands of years before the Spanish explorers in 1550."

Around 1770, Samuel Davidson purchased 640 acres, including Old Fort. He built a stockade on the land. Or was it Waddell? Reports differ:

Some say Davidson built it for the use of the white settlers; others report that Captain Hugh Waddell constructed it with Colonial Militia left "to guard and range the country, while General Rutherford led with an expedition against the Cherokee." For 20 years from 1756 to 1776, the settlement around the stockade was the westernmost outpost of Colonial Civilization.

Also surprising to some might be General Griffin Rutherford's 1776 campaign against the Cherokee, bivouacking at Old Fort. According to one report, "thirty Indian towns, along with crops and stored food, were attacked and destroyed by Rutherford and his men."

The Cherokee never fully recovered from the devastation. Most of the tribal members fled prior to the attack, so few lives were lost on either side. Rutherford is credited with the first "scorched earth" warfare in the

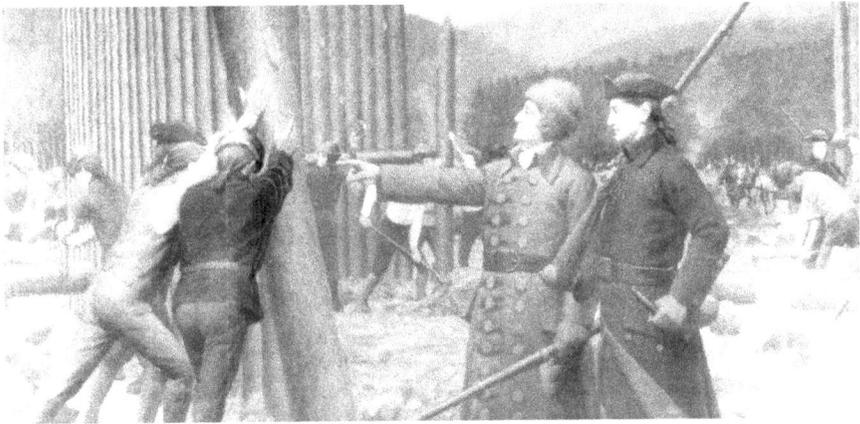

The building of a stockade fort.

Americas, so tellingly employed later by General Sherman in the Civil War. He and his men burned a great number of villages and crops as they drove the Indians farther west.

Hopefully, more true stories will be uncovered about Old Fort and its place in Western North Carolina history, because, according to historians, at least eight thousand years of human habitation existed in this area prior to the recorded period.

SHERRILL'S TAVERN

In the early part of the nineteenth century, John Ashworth built a cabin on the two hundred acres of land he had bought for fifty shillings. The tavern, at first a bare-bones overnight stop for cattle drives and stagecoach travelers, was enlarged about 1834, and by 1850, it was renamed for the new owner, a man named Bedford Sherrill. Sherrill was appointed by the 1841 General Assembly as builder and keeper of the Hickory Nut Turnpike. Also, by 1850, the name "tavern" changed to "inn." Described in an 1895 travel guide, *Mountain Scenery*, this spot had "a fine view" and was "a cool, pleasant place in summer," which suited visitors.

Mrs. James McClure Clarke, who presented a paper entitled "A History of Sherrill's Tavern" before a meeting of the Western North Carolina Historical Association on October 28, 1978, gives us an inside look at the very early hidden history of Sherrill's Tavern/Inn:

The early guests at Sherrill's were an assorted lot—traveling preachers, drovers, lawyers, politicians and occasionally prosperous families from Charleston and the East coming to the mountains to enjoy the cool summers. Some of the travelers came by stagecoach. These were the old-fashioned Albany coaches, and the horses were changed about every 8 miles. These conveyances carried nine passengers inside and had room for the driver and others on top. The driver used to blow his horn some distance before reaching Sherrill's Inn to indicate how many passengers he was carrying. The family knew how many guests to prepare for. In rainy weather the road up the mountain was often deep in mud. The driver and all male passengers had to help push the heavy coach through the deepest ruts. When the coach arrived, Mr. Sherrill would go out and offer apple brandy to the weary passengers. His black boy would take the horses to the barn and the guests would be shown to their rooms—which were small. A person sleeping in the back bedroom downstairs had to go through four other bedrooms to reach his own. But these hard-ships were soon forgotten in the tap room where apple brandy and other refreshments were available.

Some of the better-known visitors, according to Mrs. Clarke, were F.W. Pickens, the first governor of South Carolina after the state seceded from the Union; author D.H. Jacques; Walter L. Steele, secretary of the N.C. Secession Convention; and Charles Edward Bechtler, who minted gold coins near Rutherfordton. Also on the guest list were Bishop Atkinson, who was instrumental in bringing reconciliation between the Episcopal churches of the south and north after the Civil War; Millard Fillmore; Zeb Vance, a member of Congress; and Governor Andrew Johnson.

Two prominent young women also resided at Sherrill's Inn. Miss Mary Ann Morrison later became Stonewall Jackson's second wife. Her sister, Eugenia Morrison, was later wed to General Rufus Barringer.

Mrs. Clarke's historical presentation in 1978 included one particularly entertaining truth. She wrote the following humorous tidbit: "John P. Arthur, the historian, was often a visitor at Sherrill's. He was apparently inclined to excessive indulgence in drink and on one occasion signed the register—'J. P. Arthur—sober!'"

One day, unwelcomed visitors arrived at Sherrill's Tavern near the end of the Civil War; these were General Stoneman's raiders. It has been reported that a daughter of the owner shook her stockings over the eggs she was frying for the soldiers. She supposedly said, "They can eat the dust off my feet and they'll think it's pepper!"

Sherrill's Inn hosted mostly pre–Civil War North Carolina guests; however, people came from fourteen other states and Ireland, as shown in the inn's 1850s register. Then, business increased even more when the Western North Carolina Railroad extended its line. Guests kept coming, and between 1880 and 1909, Sherrill's Inn entertained people from thirty-one states and nine foreign countries

Situated on a hillside, the inn is built with special attention to early log patterns. It is a perfect example of a saddlebag log house with exterior stair.

The Sherrill family operated the inn until 1908.

WARM SPRINGS HOTELS

In 1937, James Patton built the 350-room Warm Springs Hotel in what is now Hot Springs, North Carolina. Its thirteen tall columns represented the first colonies in the United States. Nicknamed Patton's White House because of its size, the dining room could seat six hundred people. The next owner was James H. Rumbough, who purchased the springs and the hotel in 1862. President Andrew Johnson's son, Frank, met his bride, Bessie Rumbough, at the hotel. After the railroad reached Warm Springs in 1882, Rumbough felt it necessary to enlarge the already huge hotel. Only a couple of years later, the hotel burned, but the springs were sold to a group called the Southern Improvement Company.

About 1886, a spring with a higher temperature was discovered; consequently, the town changed its name from Warm Springs to Hot Springs. The Mountain Park Hotel was erected and proved to be one of the most elegant resorts in the country during its heyday: "It consisted of sixteen marble pools, surrounded by landscaped lawns with croquet and tennis courts. The Mountain Park Hotel established the first organized golf club in the Southeast with a nine-hole course."

In 1917, the federal government leased the hotel and grounds as an internment camps for German merchant sailors captured in United States harbors when war was declared. Reports indicate the internees were treated well by the townspeople, and several returned to visit after the war.

The Mountain Park Hotel burned in 1920 and was never rebuilt. Today, the springs are privately owned as a spa.

BATTERY PARK HOTEL

Touted as one of the finest resorts ever built in Western North Carolina, the Battery Park Hotel opened on July 12, 1886. Historian Milton Ready explores the Victorian-era Battery Park:

> *Each room had its own fireplace, modern steam radiator, and, a new innovation in 1886, Edison electric light bulbs. Under the dining room, billiard and bar rooms and smokers catered to "gentlemanly pleasure"… Men and women mingled freely for the first time, a modern touch, and there were no side entrances to the ladies' parlor or to the gentleman's billiard room.*
>
> *The Victorian age was a time that demanded more starched linen in a gentleman's suit, more ruffles and lace on ladies' gowns, more verandas on hotels and rocking chairs on porches, more courses on menus, and more affectations in manners and conduct. Parties, socials, clubs, the theater, walks in the park, and brisk carriage rides to Mount Mitchell or Mount Pisgah—all the heady social scene of Victorian Asheville. Prominent families in the area began to hold socials at the Battery Park. Numbers of balls and receptions were held each year, gala assemblies that attracted throngs from everywhere. Gradually, the events became seasonal—a rhododendron ball in August, an anniversary dance in July, the famous German party to greet the fall, and a Christmas hop.*

Chapter 4
People

ABRAHAM LINCOLN

Is it possible that Abraham Lincoln, the sixteenth president of the United States, might have been born in 1804 in Rutherford County, North Carolina? H. Cathey, a state legislator, alleged Lincoln's Bostic, North Carolina roots in his 1899 book. Since that time, Jerry Goodnight has written a book entitled *Looking for Lincoln amid the Rumors, Legends and Lies*. Don Norris penned another volume, *Abraham Enloe of Western North Carolina, the Natural Father of Abraham Lincoln*. Then there was Annis Ward Jackson's *Into the Twilight: A Disavowed Beginning*, in which the author described "a story of ill-fated love."

In March 2008, proponents of the Bostic birth opened a Lincoln Center in the old train depot, just a few months after the death of Tom Melton. Melton, who had collected information concerning Lincoln's ties to North Carolina, had a marker placed about a mile from Puzzle Creek—the first pieces of the puzzle of Lincoln's birth.

So, serious students of Lincoln's heritage believe the following events transpired:

> There are plenty of people who asset in all seriousness that Abraham Lincoln was born to Nancy Hanks in February 1804, two years and four months before the recorded marriage of Thomas Lincoln and Nancy Hanks in Washington County, Kentucky. They say that the toddler Abraham was nearby during that wedding, and that his mother had been carried by Mr. Lincoln, a muleskinner, to Kentucky because she was unwanted in the North

Carolina household where, as a bondservant, she had romanced the well-off businessman, cattle dealer and slave trader Abraham Enloe. There are plenty of people who assert in all seriousness that Abraham Lincoln was born to Nancy.

Scholars say that Nancy Hanks attended Concord Baptist Church in Rutherford County; however, no records to that effect have survived. In addition, these same scholars proclaim that even though there were many women named Nancy Hanks at this time, this was the Nancy Hanks who was transported—along with her young son—out to Swain County, where Enloe had moved with his family to establish a new farm.

The story continues.

Nancy Hanks had been transported along with her young son out to Swaim [sic] County, where Abraham Enloe had recently moved to set up a new farm with his family. This Nancy had been living with the Enloes on Puzzle Creek as a servant since she was about 12. When she was about 17, the story goes, she and the tall, lanky Mr. Enloe became intimately involved. Nancy accompanied the large family to their new place in Swain County, not far from Waynesville, until Nancy's pregnancy became obvious. Mr. Enloe then arranged for his friend Felix Walker, of Buncombe County, to take Nancy back to the Puzzle Creek homestead which was occupied by tenants. Nancy gave birth to Abraham there.

What happened next is anyone's guess. One report indicates that when Mr. Enloe arranged to bring Nancy and her boy Abraham back to Swain County, Mrs. Enloe did not approve, so her husband changed his mind and sent mother and son to Kentucky, where he owned a gristmill. Rumors abound. Some say Mr. Enloe paid one of his millworkers, Tom Lincoln, to marry Nancy and take care of her son. Another rumor concerns the fact that Mr. Enloe heard that Mr. Lincoln was abusing Nancy, went to Kentucky to see what was going on, and he found a drunken Mr. Lincoln. After consoling Nancy, Mr. Enloe reportedly tussled with Mr. Lincoln, who bit his nose pretty hard. What is true and what is fable? We'll probably never know. However, one account does seem to verify at least part of the rumor:

The following is published as a historical fact:

People in Kentucky always said that Abraham Lincoln was always a very large boy for his age. It may have very well been that he was several

years older than what his mother and father Tom Lincoln claimed… Jesse Head the Methodist Minister that married Nancy Hanks and Tom Lincoln always said that the couple had a black haired boy with them at the wedding. If so and it was Abraham Lincoln then there is probably no way Tom Lincoln was the boy's father. In all likelihood Abraham Enloe back in North Carolina was probably the boy's father and if so then Abraham Lincoln probably was born in that Log Cabin on Puzzle Creek near Bostic, North Carolina, and not in Kentucky.

The late Harold Ickes, secretary of the interior during the Franklin Delano Roosevelt administration related a conversation that he had heard between Roosevelt and the librarian of Congress about a private collection of Lincoln's papers and letters.

The Librarian of Congress quibbled, "Mr. President," he said, "if these letters are purchased they will become public property and will prove beyond doubt that Lincoln was an illegitimate. Shall we decline to purchase the collection, or shall we purchase it and suppress or destroy papers relating to Lincoln's paternity?" To this Ickes quoted Roosevelt as replying, "Purchase it and destroy nothing. Whether or not Lincoln was an illegitimate has nothing to do with his greatness."

LILLIAN EXUM CLEMENT STAFFORD: SUPERWOMAN

Before the Nineteenth Amendment gave women the right to vote in 1920, Lillian Clement, at the early age of twenty-six, became the first woman candidate for the North Carolina legislature and the first woman elected in the south to that seat. Many other "firsts" were significant for her. She was one of the first women lawyers; in fact, she was referred to as L. Exum Clement or "Brother Clement." She was the first to have a practice that did not include males. She practiced criminal law.

Lillian began working in the sheriff's office when she was barely a teenager, and she studied law at night with two Buncombe County attorneys, passing the bar exam in 1916 with an exceptionally high grade. Immediately, she set out by explaining her platform, which was, in her own words, "by nature, very conservative, but I am firm in my convictions. I want to blaze a trail for other women. I know that years from now there will be many other women in politics, but you have to start a thing."

And "blaze a trail" she did. Her first bill proposed private voting booths and secret ballots. Initially, the bill did not pass, so Lillian reintroduced it as "the only democratic way." She also introduced what she called the Pure Milk Bill, which mandated tuberculin testing of dairy cows and clean barns. Her divorce bill reduced from ten to five years the time a female had to wait to obtain a divorce after she had been abandoned by her husband. Lillian's most unpopular bill proposed a home for unwed mothers and delinquent girls to be state supported. She was met with bombardments of rotten vegetables and eggs because folks accused her of contributing to the delinquency of girls. In only one term of the General Assembly, she introduced seventeen bills, sixteen of which became law. In addition, Lillian served as chief clerk of the draft exemption board and helped found the local chapter of the Business and Professional Women's Club.

Lillian's daughter related a true story to illustrate her mother's compassion:

From her office window on Pack Square, Lillian noticed a young woman sitting on a bench for a couple of days. Concerned, she went down to ask if

A polling center.

National Federation of Business and Professional Women's Club.

she could help and learned that the young woman, employed as a maid for a local family, had been seduced by the son, became pregnant and was kicked out by that family and her own. In Stafford's words, "Mother brought her home; she gave birth to a daughter and after I was born and Mother was still sick, the young woman became my wet nurse."

Lillian Exum Clement Stafford died of pneumonia in 1925.

CARL AND PAULA SANDBURG

In the little mountain town of Flat Rock, North Carolina, sits Connemara Farm, the former home of Carl and Lillian (Paula) Sandburg. Although most people recognize Carl as the winner of two Pulitzer Prizes and host to heads of state, presidents and movie stars, few realize that he only formally

graduated from the eighth grade. He did attend college for four years; however, he never received a degree. That fact does not prevent us from respecting Sandburg's work. He was poet, writer, historian, biographer of Abraham Lincoln and a social activist—quite an achievement!

It was wife Paula, sister of photographer Edward Steichen, who instigated their move to Flat Rock, North Carolina, in 1945. Paula raised champion dairy goats and was fascinated by the possibilities surrounding genetic manipulation. According to historic reports, Mrs. Sandburg was famous in her own right for her goats:

> She called her animals the Chikaming herd, and it included Nubians, Saanens, and Toggenburgs. What interested Mrs. Sandburg most was breeding for production; in addition to raising the goats, she ran a commercial dairy on the farm. At its peak, the Chikaming herd had about 200 goats in her Grade A dairy operation.

So, what did Carl think about his wife's goats? In his published correspondence, there are many mentions of them, but in his poetry, there is only one reference where the goat depicted seems to have a life antithetical to those lived by Mrs. Sandburg's animals. One literary critic found the contrast and juxtaposition interesting:

> The sober-faced goat crops grass next to the sidewalk.
> A clinking chain connects the collar of the goat with a steel pin driven in the ground.
> Next to the sidewalk the goat crops November grass.
> Pauses seldom, halts not at all, incessantly goes after the grass

FRANK PROFFITT

Frank was reared in the Reese area of Watauga County, North Carolina. As a young man, he married and had six children. He made a living for them by raising tobacco and growing strawberries. In addition, he made musical instruments, such as banjos and dulcimers.

One day in 1937, a New York couple, Frank and Anne Warner, appeared in the area to buy a dulcimer from Nathan Hicks, Proffitt's father-in-law. Nathan reportedly sang a few Appalachian folk songs. The next year, the Warners returned, and Proffitt sang "Tom Dula" for them. The Warners

used one of the first battery-operated recorders to capture the verses Proffitt sang for them. Eventually, in 1945, Alan Lomax published "Tom Dula" in his collection, *Folk Songs USA*.

Then, in 1958, the Kingston Trio added the song to their stage routines; however, at this time, they changed the title to "Tom Dooley." When Frank Proffitt heard the Kingston Trio perform on *The Ed Sullivan Show*, he was shocked to hear the song written by him and his father-in-law. After filing a joint lawsuit, Proffitt and Hicks began to receive royalties several years later.

So, what was this popular song about? Here is how the legend goes:

> *Tom Dula and his lover Laura Foster lived in the North Wilkesboro, NC area. Tom Dula was a wild young buck, running around with two or three women at the same time. Foster, according to the ballad, gave him syphilis. He inadvertently passed it on to Foster's first cousin, Mrs. Ann Melton. A third woman, a Pauline Foster, was in the background as well at the time. Both Laura and Ann were pregnant by Dula. When Mrs. Ann Melton realized that her longtime affair would be exposed by the pregnancy, that the baby's health was seriously endangered, and that her own health had been compromised, all to her way of thinking because of Laura Foster, she insisted that they—Dula and she—murder Laura Foster in vengeance.*

Tom Dula was hanged May 1, 1868, for the murder of Laura Foster. What happened to Ann Melton? Mountain tales don't have to answer all the questions.

Why was the name changed from "Dula" to "Dooley"? One music critic explains a probable reason for this: "It is common in the southern mountains to shift a final unstressed *uh* sound to *ee*, so Dula was—and is—frequently pronounced as Dooley."

> *Hang down your head, Tom Dooley*
> *Hang down your head and cry*
> *Hang down your head, Tom Dooley*
> *Poor boy, you're bound to die*
> *I met her on the mountain*
> *There I took her life*
> *Met her on the mountain*
> *Stabbed her with my knife.*

Frank Proffitt began traveling around the country, accepting the hundreds of invitations he received. He apparently kept his priorities straight, as indicated by this philosophy:

> *Even with the hundreds of invitations and the travel, Frank Proffitt's first priority was always his farm work. In fact, he eventually refused to sing for fees…He sang the songs for people not out of a motive for personal gain, but to give tribute to the people who had taught him the songs. He said the songs helped him remember his older family members and even picture them.*

David Brose of folkschool.org explains his view of the song. He writes, "As a North Carolina resident I may be biased toward this song, but I find the fact that the ballad(s) and the legends surrounding the man continue to circulate in oral tradition some 140 years after his death to be fascinating."

Of course, we must all remember that facts must never interfere with telling a good story.

Dr. Mary Frances "Polly" Shuford

Mary Frances Shuford was born in 1897 in Asheville, North Carolina. One of her fondest memories centers on the twenty rooms of the house where she and her family lived. When Polly's father lost a great deal of money, her mother took in boarders and obviously generated enough revenue for the family to live comfortably. Polly's reminiscences are recorded in a Shuford oral history collection:

> *In summer, mother would stack them [boarders] up. She really put them in here. And there were four big rooms upstairs, and one bedroom downstairs that she could take people in the house. And then she got rooms all over the neighborhood. Well, sometimes she'd have to have two dinners, or two meals served, and she'd have to serve the children first, which was alright with us. And then she'd have the grown people next, which was alright with the grown people, you know. And she had a marvelous cook: Lina Collins. And she had a marvelous garden. And this young lady from Kentucky asked me what these summer boarders did for entertainment here. And I said, they came down, sat on the porch and waited for dinner to be hollered. It's all I ever saw them do. And after they got through with dinner, they sat around and waited for supper. Eating was the chief entertainment. Mother never*

did anything to entertain them. They'd get up card games. Other women would have their embroidery, but these people would come up from Georgia and Florida, and Mississippi, and they stayed all year. There's no air conditioning down there then you know.

Polly graduated from Shorter College and taught at a country, one-room schoolhouse, beginning in 1918, earning twenty dollars a year. Then, she entered Columbia University to do graduate work in bacteriology, graduated and moved back to Asheville to open her own lab in 1919. By 1922, she had decided her true love was medicine, so she went back to Columbia University to become a medical doctor. "I studied medicine because I was interested in it," Polly recalls. "Because it was a challenge, and I wanted to know." She went to Columbia Medical School for two years and then headed for Europe, where she attended the University of London and continued her studies there. She decided to transfer to the University of Chicago in 1924. She recalls the quota factor at all schools she attended; they permitted only 10 percent women.

Graduating from University of Chicago Medical School, Polly Shuford asked for a leave of absence before she went back to finish her residency. In 1935, Dr. Shuford opened her medical office and was affiliated with a small private hospital in Asheville during the Depression years.

She talks about the Depression:

It hit very bad. The Central Bank failed. All the banks were closed except for the Wachovia. And the city of Asheville had money in the Central Bank, and nobody got a dime from that bank. And it was a very sad time, and we haven't gotten over it yet. There was eight million dollars lost I think. And the Mayor committed suicide, and one banker that lived on this street committed suicide and I think there was one or two other.

Other problems arose. Hospital beds were not available at Mission, Biltmore or St. Joseph's Hospitals. Dr. Shuford began assisting with tonsillectomies in her home. Her cook, Anna Wilson, served as nurse, while Dr. Charles Norburn performed the surgeries. Anna Wilson fixed up a little room off the kitchen for recuperating patients. In a humorous manner, she related: "I had some mighty good grape juice. And I had a patient who made very fine blackberry wine. And she also made very fine fruit cakes. So I said we'd…keep the patient back off the kitchen, and we'd serve wine and fruitcake to the staff. I never had any trouble getting a surgeon to come."

Amos Owens: "Cherry Bounce King"

How did this mountain man earn the title of "Cherry Bounce King"? His formula is recorded: "He mixed a generous portion of his finest corn whiskey with a few dashes of sourwood honey and cherry juice, having been trod from the cherries by the bare feet of his beautiful daughters, in true Old World."

Described as a "rotund, red-faced leprechaun" of an Irishman, his high-pitched whiskey tenor voice commanded the awe of his friends and foes. Owens was the epitome of the Appalachian moonshiner of the 1800s. According to historical accounts by those who knew him best, he never considered his whiskey making illegal or immoral. He reasoned that he owned the apples, corn and cherries; he owned the land and the copper pot still. That reasoning, however, did not keep him out of trouble with the law, but he never tried to run away and always appeared in court on time. Lee Weathers, former editor of the Shelby, North Carolina *Star*, gave this true account:

> *Uncle Amos was a household word in these parts before the turn of the century. I remember having seen him once as a child when my family lived near the Seaboard depot…Owens was sitting in a passenger coach, riding to Charlotte for his fourth trial in Federal Court for making and selling moonshine liquor and refusing to pay the revenue…He was a jovial passenger, wearing a high beaver hat and a Prince Albert coat. A pair of homemade leather suspenders held up his baggy trousers. Everybody seemed to know Amos. He greeted his friends and moonshine customers with a grin, admitting that he might be sent back to Sing Sing in Ossining for a "post graduate course."*

To further illustrate Amos Owens's sense of humor and spunk, this true story was often told:

> *Even while on trial, Amos would proudly defy his captors by stationing one of his cronies from Cherry Mountain right outside the courthouse with a wagonload of whiskey, the spirits being covered by sweet potatoes and chestnuts. A usual load was "20 bushels of 'taters and 40 gallons of corn whiskey." By the time his trial was over, he would have in hand more than enough cash to pay off his lawyer and his fine.*

In 1901, schoolteacher M.L. White wrote and published a pamphlet depicting the picaresque life of Amos Owens, who dictated to White the circumstances, describing his marriage as a young man.

Amos Owens was married once and but once, to Miss May Sweezy. When his time came to marry he got on his horse, "Old Hickory" and rode over to old man Sweezy's. The old man was worming and suckering tobacco, and on seeing Amos, got off the original observation [sic]. "Light and look at her saddle"—"I han't got time," said Amos. "Where is Mary Ann?: "She has gone to peel some walnuts to dye some cloth, what's up?" "Oh, nothing, particular," said Amos, "we thought we'd marry this evening." "Marry! The devil," quoth the old man, pretending as is usual under such conditions, to be greatly surprised. "No I just wanted his daughter," quoth the irrepressible Amos, "and had no idea of marrying the whole family."

The old man grinned, humped himself over a tobacco plant, and Amos hunted up the future partner at [sic] his joys and sorrows. She was found, bare-headed and barefooted, coming with a basket of walnut hulls. This she delivered, and making no other changes in her toilet except to put on her home made shoes and "wagon cover' bonnet, she gaily mounted on old Hickory behind Amos. They hunted up a justice of the peace and stated their business. He soon pronounced the ceremony, and was then and there tendered a coonskin and a quart bottle of brandy. He threw the coon-skin on the floor and then and there took an observation of the heavens over the end of that bottle. Amos brought her to his three story house, which was not three stories high but three stories long, and she that evening milked the cow and set a hen, while Amos made an ox-yoke and repaired his wagon harness. That is all there is in the way of romance about his marriage, and it is to be observed that he has been kind to his family and through all his privations and vicissitudes, she has been a help-meet true as steel.

When he was over seventy years old, Amos Owens agreed in Charlotte's federal court to discontinue his manufacture and trade of illicit whiskey. He was true to his promise and, according to history, never again fired his distilleries.

COLONEL EPHRIAM BREVARD, MD

Born in 1744, Ephriam Brevard, a socially prominent young man, studied medicine at Princeton College. At the time of the Revolutionary War, he drafted the Mecklenburg Declaration of Independence, the first made in America during the American Revolution. No original text exists; however, the Mecklenburg declaration was declared authentic, and according

to historians, "North Carolinians were the first Americans to declare independence from Britain."

Brevard fought in the Revolutionary War. He was taken prisoner and suffered severe dysentery, and reports indicate that Andrew Jackson's mother nursed him. He did not recover and died in 1781. A monument in front of Brevard City Hall honors Ephriam Brevard. It says: "Fought bravely and died a martyr to that liberty which none loved better and few understood so well."

LILLIAN FRYE

After their marriage in 1895, Lillian and Amos Frye moved to the area now known as Bryson City, North Carolina. Lillian wanted Richard Morris Hunt, the Biltmore Mansion's key architect, to design her new home. She scheduled an appointment and traveled for a day and a half by horse and buggy to Asheville to meet with him. They both agreed that French doors and many windows would give the residence that light and airy look that Lillian so desired.

Ten bedrooms and six bathrooms provided ample space for special visitors. Built from the finest maple, oak and chestnut, the exterior of the house was covered with rustic poplar tree bark. The first building in the area to have electricity, a telephone and indoor plumbing, the finest workmanship went into the residence. Hand-forged hinges adorned cabinets, while bathroom fixtures bore the cobalt blue logos of early infantrymen. Lillian used to remark, "Biltmore Mansion likes to brag that they were the first to have working toilets in a house, but we flushed long before they did." Then she would qualify that statement with, "Only because Biltmore took longer to build!"

Lillian, an early environmentalist and naturalist, invited traveling artists and educators to her home and held social gatherings. She liked earthy primitive objects and had a kiln in the basement to fire her handmade pottery. She stored looms in the attic to weave cloth. Using natural stains such as pokeberry, Lillian stained the walls of her new home. She dabbled in blacksmithing. She was also an excellent cook; her basement kitchen had an open hearth, where she roasted quail, duck, pheasant and venison.

The Frye's devoted servant, Emma, prepared food on a wood stove in a separate basement area called "the summer kitchen." She used a dumbwaiter to send dishes upstairs to the thirty-foot-long dining room, referred to as "the banquet room," where Emma's husband, Grover, and other servants assisted in formal serving. Grover passed a twenty-eight-inch turkey platter and then

People

Right: A loom.

Below: Lily Pond.

served vegetables from large bowls. Starched white linens, freshly cut flowers and fine china, with delicate tiny roses, graced the table.

Described as a "working tornado," Lillian Frye had many interests. The first woman accepted to the law school of the University of North Carolina, she completed her studies in 1911 and become the second woman to pass the North Carolina bar examination. Having earned the distinction of being the first female member of the North Carolina Bar Association, she practiced law in partnership with her husband and her son-in-law.

Lillian died in 1957, but family members say her influence lives on. She was instrumental in the establishment of the Girl Scouts in Western North Carolina and also used her strong personality to support women's rights.

Farmer Bob

His real name was Robert Lee Doughton, and he was a U.S. congressman and also a sincere advocate and supporter of the Blue Ridge Parkway. In 1961, the largest recreation area (six thousand acres) on the Blue Ridge—known as the Bluffs—was renamed in honor of Farmer Bob's devotion to preserving the trees, native flowers, wildlife and monarch butterflies that pass through as they migrated to Mexico.

One of the most interesting preservations is noted on a sign at the Wildcat Lookout:

In the hollow below is the log cabin home of two hardy pioneers, Martin Caudill and his wife, Janie. Martin's father, Harrison Caudill, also lived in the Basin Creek Cove about a mile down the creek from this cabin. Martin raised a family of 14 children. Harrison was the father of 22. Martin's clearing, still traceable, provided corn, potatoes and other needs for the table.

In addition to his Blue Ridge Parkway activities, Congressman Doughton was the subject of tax-related political cartoons, one of which was entitled, "What's the Matter with That One, Bob?"

This World War II cartoon shows Congressman Robert Doughton, Chairman of the House Ways and Means Committee, looking disgustedly at a lemon, labeled "Income Tax," that has been squeezed dry. Behind him, Uncle Sam points to a large lemon, labeled "Sales Tax," and asks, "What's

the matter with that one, Bob?" Meanwhile, the cartoonist's small signature bear [sic] *hands Doughton a pair of binoculars. In October 1943, the Treasury Department announced that the country needed another $10 billion in taxes to support the war effort. Doughton responded indignantly that the people would not be able to support such an increase. Berryman* [the cartoonist] *suggests that the country again consider the imposition of a national sales tax, an idea that was brought up periodically but never implemented because many people felt it would fall unfairly on those least likely to be able to afford it.*

In another interesting cartoon, artist Clifford Kennedy Berryman pokes fun at the tactics of the government in promoting the war effort by freezing prices and raising taxes:

[This] *World War II cartoon shows Congressman Robert Lee Doughton, Chair of the House Ways and Means Committee, telling Senator Walter George, Chair of the Senate Finance Committee, "It's perfectly simple." He indicates a large three-paneled sign headed, "The New Tax Plan." In the first panel, a taxpayer, shown as John Q. Public "Listens to the President's speech on the radio and wants to give away everything he has." In the second, showing the taxpayer encased in a block of ice holding his money* [sic]. *Office of Price Administration Head "Leon Henderson comes along and FREEZES him in that attitude." In the third, Secretary of the Treasury "Henry Morgenthau comes with an ice pick and a basket and TAKES what he needs."*

Although Farmer Bob was the subject of political cartoons, that attention apparently did not deter him from what he felt was his civic duty as an advocate of the Blue Ridge Parkway. Today, Kelley School, a two-room schoolhouse originally built in 1924, has been preserved, although weather and time have taken their toll.

BIG TOM WILSON

Thomas D. "Big Tom" Wilson was born in a cabin on the Toe River in 1825. When he was twenty-seven years old, he married a woman named Niagra Ray. Within the year, they had moved to the Cane River area, where Big Tom was employed as gamekeeper at Murchison Preserve.

Hidden history concerning Big Tom was revealed by a northern author, Charles Dudley Warner, in his book entitled *On Horseback: A Tour in Virginia, North Carolina, and Tennessee*. While traveling through Western North Carolina, Warner, who spent quality time with Big Tom, wrote of visits with the legendary hunting and mountain guide, hunter, fisherman and farmer.

Warner relates the following:

> *Big Tom's plantation has an open-work stable, an ill-put-together frame house, with two rooms and a kitchen, and a veranda in front, a loft, and a spring-house in the rear. Chickens and other animals have free run of the premises. Some fish-rods hung in the porch, and hunter's gear depended [sic] on hooks in the passage-way to the kitchen. In one room were three beds, in the other, two, only one in the kitchen. On the porch was a loom, with a piece of cloth in process.*
>
> *Big Tom's most striking attribute was his spiritual vitality, not his physicality: Big Tom Wilson, as he is known all over this part of the state, would attract attention from his size. He is six feet and two inches tall, very spare and muscular, with sandy hair, a long, gray beard, and honest blue eyes. He has a reputation for great strength and endurance; a man of native simplicity and mild manners.*
>
> *There was an entire absence of braggadocio in Big Tom's talk, but somehow, as he went on, his backwoods figure loomed larger and larger in our imagination, and he seemed strangely familiar. At length it came over us where we had met him before. It was in Cooper's novels. He was the Leather-Stocking exactly. And yet he was an original; for he assured us that he had never read the "Leather-Stocking Tales."*

Perhaps Big Tom's most notable feat occurred when the noted bear trapper (killing 114 bears in his lifetime) found the body of Dr. Elisha Mitchell of Yale, for whom Mount Mitchell was named. Charles Dudley Warner explores details behind this tragedy:

> *Professor Mitchell (then in his sixty-fourth year) made a third ascent in June 1857. He was alone, and went up from the Swannanoa side. He did not return. No anxiety was felt for two or three days, as he was a good mountaineer, and it was supposed he had crossed the mountain and made his way out by the Caney River. But when several days passed without tiding of him, a search party was formed. Big Tom Wilson was with it. They explored the mountain in all direction unsuccessfully. At length*

People

Big Tom separated himself from his companions and took a course in accordance with his notion, of that which would be pursued by a man lost in the clouds or the darkness. He soon struck the trail of the wander, and, following it, discovered Mitchell's body lying in a pool at the foot of a rocky precipice some thirty feet high. It was evident that Mitchell, making his way along the ridge in darkness or fog, had fallen off. It was the ninth (or the eleventh) day of his disappearance, but in the spare mountain air the body had suffered no change. Big Tom brought his companions to the place, and on consultation it was decided to leave the body undisturbed till Mitchell's friends could be present.

Mitchell's body was carried to Asheville and buried there; however, years later, a group of scientists wanted the body taken to the summit of Mount Mitchell. They were unable to dig a traditional grave, but they removed all loose stones, placed Mitchell's body in the one- to two-foot grave and replaced stones over all. No monument or headstone signals his final resting place. According to author Warner, "the mountain is his monument. He is alone with its majesty. He is there in the clouds, in the tempests, where the lightings play, and thunders leap, amid the elemental tumult, in the occasional great calm and silence and the pale sunlight. It is the most majestic, the most lonesome grave on earth."

When Big Tom Wilson died at the age of eighty-five, the *New York Times* on February 6, 1908, revealed the following in his obituary:

Big Tom was one of the pioneer settlers of the mountains and held the record for having killed more bears than any one else. He had 110 to his credit, and his son, Adolph, ninety. He was known as the guide of the Black Mountains. He was seven feet tall and weighed 250 pounds. Big Tom Wilson found the body of Professor Elisha Mitchell of Yale, for whom Mount Mitchell, the highest peak east of the Rockies, was named.

Big Tom died in 1909. Today, a replica of his cabin is displayed inside Mount Mitchell State Park and a Big Tom Wilson Preserve exists on the western slopes of Mount Mitchell. While reports about his actual height vary from historian to historian, one fact is certain—he was definitely a mountain hero.

President William McKinley

Of course, everyone would expect President William McKinley's visit to Asheville to make newspaper headlines, but who would have guessed what actually transpired on that beautiful late spring day of June 14, 1897? Everything actually started with a routine welcoming, as reported in the next day's issue of the local newspaper:

> *The President and party arrived here from Chattanooga in beautiful weather, warm, but tempered by a delightful breeze, at 11:40 o'clock. They were met at the station by a local Reception Committee and the Asheville Light Infantry. The President was received by Mayor Rankin and E.P. McKissick, manager of the Battery Park Hotel, to which all of the party went for luncheon. The streets were crowded, and there were many decorations including National flags flown by the hundreds.*

According to a published newspaper article with daring headlines— "M'Kinley Visits Biltmore: Refuses to Enter George Vanderbilt's Home Unless His Newspaper Guests Can Go Along"—President McKinley's

Park Square.

requests were not honored. One paragraph from the June 14, 1897 newspaper account explains the problem:

> *Permission to enter Biltmore House, George W. Vanderbilt's mansion, had been refused to the newspaper men, while extended to other members of the party. Mr. Vanderbilt is abroad, and his representative, Charles McNanoee, is with him. In the absence of both, the estate is governed by E.J. Harding, said to be an Englishman by birth…He objected strongly to receiving any members of the party, other than the President and his Cabinet and the ladies with them. He even refused permission to McKissick, manager of the Battery Park Hotel, in charge of the party here, and in the course of conversation had with two members of the committee, said "Mr. Vanderbilt spits on newspaper notoriety, and so do I."*

President McKinley, according to the article, did not respond well to this edict, because he considered the newspapermen his invited guests, and to him, they were just as important as his cabinet members. If they were barred from the mansion, he, himself, "would not step one foot inside the estate." As a result of the president's determination, the newspapermen were admitted.

One more stop came before the group's visit to Biltmore House. The president and his entourage traveled to the Young Men's Hall of Colored People, a gift from George Vanderbilt. This stop also made the local paper— with a header entitled "Seven Negroes Fan the President." This is what happened, according to a June 14, 1987 column:

> *The hall was filled to its utmost capacity of colored people, comprising the laboring classes as well as colored politicians and their wives and children. With Congressman Pearson on one side for ten minutes he* [the president] *shook hands at a rapid rate with all who were presented to him. Presently, the President asked for air, and seven colored men fanned him while the handshaking went on.*

Next, the president and his traveling companions arrived at Biltmore House and apparently enjoyed their visit there. Everyone especially liked the library. Mrs. McKinley was honored with a special bouquet from the gardens before leaving for a ride over the French Broad boundaries of the estate—from the river cottages to the entrance lodge. And according to reports, "the Biltmore incident was closed."

FIDDLIN' BILL HENSLEY AND OSEY HELTON

Bill Hensley lived by his philosophy of life: "The only way to live a long life is to enjoy every minute of every hour in every day in every year. To get the most out of life is to put the most into the least time." A country fiddler, Bill, with his handlebar mustache overpowering a thin red face, his short stature and his habit of sitting cross legged—his legs looked like "the corner of a rail fence"—always drew photographers who captured beautiful Depression-era portraits. His fiddlin' produced "a hair-raising sound, an interesting bag of tunes, and charisma. His plain wool shirt, overhauls, and suspenders depicted the mountain man he was so proud to be," proclaimed his grandson, Clifford Lance.

Osey Helton and his brother, Ernest, often teamed up for public performances. By 1924, they accompanied fiddler J.D. Harris, making records for Broadway and Ikeh. In 1917, when WWNC radio signed on, the Helton's Old Time String band performed. Chesterfield Meals sponsored them. This trio then appeared on the *Old Fashioned Farm Hour*. Osey liked to play for house dances, and sometimes he received a monetary contribution. If he got no pay, he was happy, playing for his love of music.

The Mountain Dance and Folk Festival fiddle-off contest presented both Bill and Osey, who drew great crowds on Friday and Saturday nights. Their performances were well received, although their personalities, as reported in the *Asheville Citizen-Times*, were totally opposite:

> One of [Hensley's] *most famous feuds was the musical and bloodless feud with the late Ozzie Helton. They were known as "co-deans" of fiddlers of the Appalachian mountain region for decades, both being claimants of the championship of the area. Directly opposite in dispositions and fiddling techniques, the two men on many occasions played to a tie in the applause opinions of thousands in festival audiences. Where Fiddlin' Bill was always exuding an impish personality, Ozzie was taciturn, serious-minded and more the melancholy type...An example of the techniques of Fiddlin' Bill and Ozzie emphasizes the character of Bill. When a piece of music has been completed before an audience by Bill, he is likely to kick out his foot, striking his heel on the floor in a half turn. Ozzie just stopped playing, rested his fiddle in the crook of his arm, straightened his walrus mustache and waited until the announcement was over and he could begin again. Ozzie was of even temper and sometimes grinning big at Bill's sallies and carryings-on. He never got mad at Bill.*

People

LOUISE KING HOWE BAILEY

Born July 6, 1915, Louise was a great-great-granddaughter of Judge Mitchell King, one of the first residents of early Flat Rock's summer colony. She wrote nine books, and for forty-two years, she was a columnist for the *Hendersonville Time News*. She was the recipient of the prestigious Long Leaf Pine honor, bestowed upon her by the governor of North Carolina.

Louise knew Old Flat Rock probably better than anyone else, and she expressed her knowledge in her newspaper column, "Along the Ridges":

Flat Rock is a mosaic of diverse lives and times. Its fields and streams were once claimed as hunting grounds by the Cherokee Nation; its rocky soil sustained stalwart men and women who accepted land grants after the Revolution and carved a homeland out of a mountain wilderness. These were the Early Settlers. It was a place of respite for businessmen and planters and their families escaping malaria and the oppressive summer heat of coastal South Carolina. Historians wrote of merchants from the seaport of Charles Towne meeting with Cherokee braves on the "Great Flat Rock" to trade beads and trinkets and sometimes ammunition for valuable hides and furs to ship to European markets. In 1807 the "great flat rock" gave its name to the pioneer settlement that was growing up around it.

Louise Bailey's historical remembrances included St. John in the Wilderness, the first Episcopal Church in Western North Carolina. Her columns also focused on prominent people of Flat Rock. Her descriptions are crisp and interesting:

About 1839 Christopher Gustavus Memminger, a Charleston attorney, built a summer home in Flat Rock, calling it Rock Hill. When appointed by Jefferson Davis to the position of Secretary of the Confederate Treasury, Memminger urged Davis to remove the southern capital from Richmond to Rock Hill, thinking Glassy Mountain, rising behind his house, would offer protection. But Glassy became a hiding place for deserters and bushwhackers.

Columnist Bailey's forte was, perhaps, writing about her human interest true stories, such as this one:

A popular gathering place for the lads of Flat Rock was Markley's Blacksmith Shop, founded by John Markley and continued by his sons

St. John in the Wilderness, Flat Rock.

James and Garfield. A highlight of summer was rounding up all of the horses and taking them to be shod. Fascination lay not only in the strength and skill of the blacksmiths, but in their homespun philosophy that made its point through tales told by the Markleys for both entertainment and example.

Perhaps through Louise Howe Bailey's interest in the history of the area, her jotting down notes while still in high school and her sharing her store of knowledge through her newspaper columns, books and lectures, she has kept this rich history alive. Louise writes often of Dr. King's medical education and subsequent influence in the area of Flat Rock:

After graduation from the Medical College of south Carolina, King had sought further study in Germany, where he became friends with a fellow student Otto van Bismarck. Their correspondence continued throughout their lives and is now in the Library of Congress in Washington. Dr. King

built an office behind his house and there carried on his medical practice. When an epidemic of yellow fever struck the Jacksonville, Florida, area in the 1880s, Dr. King, realizing the disease did not occur at higher elevations, urged the Florida doctors to send convalescent patients to an infirmary he set up for them in Hendersonville. Thus, the Hendersonville area became known to Florida residents, and a thriving tourist business has resulted.

A beloved storyteller and historian of Henderson County, Louise Bailey passed away Sunday, December 27, 2009.

ORVILLE HICKS

As a boy, Orville Hicks lived with his parents and siblings on a farm in the hollow. His childhood was filled with the folktales his mother, Sarah Harmon Hicks, told her children as they went about their daily chores. Sarah had heard her grandfather and her father tell—time and time again—these stories. In her book entitled *Orville Hicks: Mountain Stories, Mountain Roots*, author Julia Taylor Ebel relates Hicks's talent:

> *Storytelling comes naturally to Orville Hicks. After all, he grew up hearing Jack Tales and other folktales every day of his life. His mother entertained her children with stories as they worked alongside her: gathering herbs, tying galax bunches to sell, working in the garden and shelling peas. Many of the stories can be traced to Europe and take the listener back to a quieter place and time before telephones and electricity. Through Orville's eyes, listeners will recognize the thread of story that is woven into every aspect of his life, beginning with his poem, "My Old Mountain Home."*

> *I'd like to go back to my childhood days—*
> *No car, no TV, no telephones.*
> *Just a simple way of living*
> *In my good old mountain home.*

Orville Hicks is a North Carolina Heritage Award recipient—younger than most who are chosen. The collection of his stories, *Jack Tales and Mountain Yarns as Told by Orville Hicks*, transcribed by Ebel, received the American Folklore Society's Aesop Accolade. She explains the common experiences of Orville and Jack:

Both are mountain boys—real mountain boys. Both have know the land they called home. For Orville, every hill, ridge, and holler around his homeplace has a name. If his mama said she was going to "pull galax" in Blackburn Holler or up in Deadlock, the family would know where to find her. Like Jack, Orville often walked the hills. He knew all the paths. He knew the long walk down to Valle Crucis where his father would sell a "hog ham." The "halfway log" offered a welcomed resting spot on the return up the hill. He knew the winding NC 194 that led from the school at Valle Crucis up to Rominger Road. At the "Big S Curve," he and a cousin would run to meet a car at the top of the curve and then run downhill to the lower curve before the car arrived. The same road winds through Matney and on to Banner Elk. Like Jack, Orville is a trader. He finds all sorts of interesting relics of mountain history, including old banjos and dulcimers.

Maybe Orville learned from Jack, or perhaps Jack is the image of many mountain boys. Both are probably true.

"Cyclone Mack" McClendon

Why the nickname of "Cyclone Mack" for a Western North Carolina revival preacher? Between 1910 and 1927, McClendon conducted tent-revival services, preaching with a booming voice. He also broadcasted radio programs, narrating with his extremely loud voice. He was not particularly subtle in his subject matter, and few people escaped his wrath. According to historian Samuel Claude Shepherd, McClendon's sermons were not exactly what one would expect of a tent-revival preacher:

Cyclone Mack condemned preachers for perfunctory, mechanical, stereotyped preaching that deals out soothing syrup on a spoon. He told one audience that religion "means being on the square and doing right, not going to church." In another sermon, he referred to church members as "Pharisees" and "religious pachyderms who are so crooked that they have to screw their shoes on every morning. He could draw big crowds but he was not likely to win new converts who would join churches.

One of Cyclone Mack's favorite venues was frequently broadcasting famous radio fights to crowds who had gathered on the street to hear this eccentric preacher.

People

FRANKIE SILVER

Many different versions of Frankie Silver murdering her husband Charlie have appeared in documentaries, magazines, books, essays and articles. This "true-crime" has also been retold in plays, ballets and ballads. According to one historian, "One of the few certainties about Frankie Silver is that she was hanged for the murder of her husband Charlie in Morganton, North Carolina, on July 12, 1833." Definitive facts are still missing; however, perhaps the most common version of the murder goes as follows:

Frankie killed Charlie in a fit of jealous rage three days before Christmas 1831. She suspected him of infidelity with another man's wife and decided to exact her revenge as he lay sleeping on the floor with their baby girl. Quietly removing the child from his arms, she then struck Charlie's head with an axe. The first blow, however, did not immediately kill him and he thrashed around the house mortally wounded. Frankie hid under the covers of their bed, eventually coming out when she heard his body hit the floor. She then took another swing with the axe, this time completely severing his head. Frankie attempted to conceal the evidence of the murder by chopping the body into pieces and burning them in the cabin's fireplace. Following this all-night affair, Frankie went to a relative's house the next morning to announce that Charlie had gone hunting and had not returned.

A search of the frozen river and surrounding countryside did not locate Charlie. A distressed Silver family brought in a slave "conjure man" from Tennessee to divine the location of Charlie. Using a glass ball dangled from a piece of string, the conjure man determined that the missing man was still in his cabin. A thorough investigation of the home and surrounding area revealed bits and pieces of charred bone, a heel iron from Charlie's shoe, and a pool of dried blood under the puncheon floor. Frankie was immediately arrested.

After Frankie was tried and convicted, she was sentenced to be hanged. She broke out of jail, disguised herself as a man and followed behind her uncle's wagon. A sheriff's posse went after Frankie. Her escape was short-lived, and she was returned to jail. Her execution day arrived on July 12, 1833, and the sheriff asked her, "Do you have anything to say." Frankie's father intervened, shouting to his daughter, "Die with it in ye, Frankie!" Frankie did have something to say, but she asked permission to sing—not say—what she was feeling. She rendered a ballad, and the sheriff placed

a noose around her neck, making her the first woman to be hanged in North Carolina.

The *Lenoir Topic* published the following blurb on Wednesday, March 24, 1886, with the headline entitled "Francis Silvers' Confession—*Morganton Paper*." "We publish, by request, the following confession of Francis Silvers, who was hanged in this place on the 12 of July 1833, for the murder of her husband. Some of our readers will remember the facts in the case." That published farewell song follows:

This dreadful, dark and dismal day
Has swept my glories all away,
My sun goes down, my days are past,
And I must leave this world at last.

Oh Lord, what will become of me?
I am condemned you all now see,
To heaven or hell my soul must fly
All in a moment when I die.

Judge Daniel has my sentence pass'd,
Those prison walls I leave at last,
Northing to cheer my drooping head
Until I'm numbered with the dead.

But oh! That Dreadful Judge I fear;
Shall I that awful sentence hear:
"Depart ye cursed down to hell
And forever there to dwell"?

I know that frightful ghosts I'll see
Gnawing their flesh in misery,
And then and there attended be
For murder in the first degree.

There shall I meet that mournful face
Whose blood I spilled upon this place;
With flaming eyes to me he'll say,
"Why did you take my life away?"

People

His feeble hands fell gently down,
His chattering tongue soon lost its sound,
To see his soul and body part
It strikes with terror to my heart.

I took his blooming days away
Left him no time to God to pray,
And if his sins fall on his head
Must I not bear them in his stead?

The jealous thought that first gave strife
To make me take my husband's life,
For months and days I spent my time
Thinking how to commit this crime.

And on a dark and doleful night
I put his body out of sight,
With flames I tried him to consume,
But time would not admit it done.

You all see me and on me gaze,
Be careful how you spend your days,
And never commit this awful crime,
But try to serve your God in time,

My mind on solemn subjects roll;
My little child, God bless its soul!
All you that are of Adam's race,
Let not my faults this child disgrace.

Farewell good people, you all now see
What my bad conduct's brought on me—
To die of shame and disgrace
Before this world of human race.

Perhaps, according to historians, Frankie's "confession" was not sung by Frankie Silver after all. A consensus suggests it was written by a man named Thomas W. Scott, a school teacher who lived in Morganton at the time of the execution. Frankie's tale continues to inspire novelists, writers and ballet companies. The legend lives on.

DANIEL BOONE

Practically everyone is familiar with Daniel Boone's boyhood and young manhood in the Western North Carolina mountains and his cabin at Holman's Ford, his hunting trips into the mountains and his amazing survivorship while he fought Indians.

Probably few people have heard the story of Boone's split bullet. This is how one historian reports the rise and fall of that remarkable tale:

> *About 1890 John K. Perry and another were felling trees in Ward's gap on Beaver Dams, Watauga County, when Perry's companion cut a bullet in two while trimming a young poplar. He remarked that it might have been fired there by Daniel Boone, as it was on his old trail. Perry said that whether Boone fired it or not it should be a Boone bullet thereafter. So, he filed two corners off a single nail and pressing the point of the nail thus filed on to the clean surface of the split bullet made the first part of a B. Then he finished the second part by pressing the nail below the first impression and found he had a perfect B. Filing a larger nail in the same way he made the impression of a D, which completed Boone's initials. This was shown around the neighborhood for a number of years, and most people contended that the bullet really had been fired from Boone's rifle. But in June, 1909, Mr. Perry disclosed the joke rather than have the deception get into serious history.*

The tall tale proved to be a great source of mountain conversation; however, John K. Perry finally revealed the Daniel Boone split bullet story as a harmless hoax.

Chapter 5
Education

BRIEF HISTORY

In 1914, John Preston wrote *History of Western North Carolina.* In Chapter XVII, entitled "Schools and Colleges," he declares, "North Carolina has little reason to be proud of her early history in the case of education. For years there was greater illiteracy in this State than in any other, and the improvement of late years has not been any greater than it should have been."

Preston calculated that public schools began in 1840 with 777 students and increased to 4,369 by 1860. Students attending colleges, academies and primary schools across the state of North Carolina grew from 18,681 in 1840 to 1,777,400 in 1860. What was happening in the mountain area?

In 1782, the first school west of the Blue Ridge opened and was taught by Robert Henry. From 1797 to 1814, the Reverend George Newton lived in Swannanoa and taught at Newton Academy. Interesting is the fact that Newton Academy was the sole institution in the United States that was called an "academy." Built of brick, the school seemed to perch on the top of a hill. The building was wide and long, with one floor only, which was divided into one large and one small room.

SCHOOL DAYS: THE BLAB SCHOOL

Thanks to the research of Colonel J.M. Ray, who wrote in great detail in *Lyceum* in 1891, we are privy to those early Western North Carolina schools. We are introduced to another hidden history: Old-Field School and what

we would consider antiquated teaching methods. As we might expect, these schools were in session only when it was not "crop time," and classes were attended by children, both young and old. Following is a detailed description of Old-Field School:

> *All were jammed into a one-room log cabin with a fireplace at each end, puncheon floor, slab benches, and no windows, except an opening made in the wall by cutting out a section of one of the logs, here and there. The pedagogue in charge (and no matter how large the school there was but one) prided himself upon his knowledge of an efficiency in teaching the "three R's"—read', 'ritin and 'rithmetic—and upon his ability to use effectively the rod, of which a good supply was always kept in stock. He must know, too, how to make a quill pen from the wing-feather of goose or turkey. The ink used was made from poke-berries and was kept in little slim vials partly filled with cotton. These vials not having base enough to stand alone, were suspended on nails near the writer.*

Although a public fund supported all the schools, teachers boarded with students' parents and traveled daily to their designated school buildings. Students studied their lessons aloud, including spelling exercises. This was called the Blab School. Because few books existed, spelling was taught by a singsong or chant, so children learned to spell, but oftentimes, they could not recognize the letters of the alphabet, even though they were written on the walls with charcoal. What we know today as spelling bees proved an exciting part of the educational program; however, these contests were quite different back then, according to historian, Colonel J.M. Ray:

> *Two of the good spellers of the school were appointed by the teacher as captains, and they made selections alternated from the scholars for their respective sides in the spelling match. The first choice was determined by spitting on a chip and tossing it up, the captain tossing it asking the other "Wet or dry?" and the other stating his choice. If the chip fell with the side up as designated, he had "first pick" of the spellers, and of course selected the one thought best. If he lost, his opponent had first pick. Another plan was "Cross or pile?" when a knife was used the same way, the side of the handle with the ornament being the cross.*

Colonel Allen T. Davidson reminisces about his school days on Johnson's Creek when he was six years old in 1825.

Education

The first schoolmaster I remember was an old man by the name of Hayes. He was a good old man, and had a nice family, and had come to that back country to "learn the young." We could not then get spelling-books readily. I had none, and was more inclined to fun than study. The old man or his daughters dressed a board as broad as a shingle, printed the alphabet on it, bored a hole through the top, put a string in it, tied it around my neck and told me to get my lesson. I did not make much progress; but was greatly indulged by the old man, and "went out" without the "stick," which was the passport for others. The old man wore a pair of black steel-rim spectacles, with the largest eyes I ever saw, and was a great smoker. There were no matches in those days, and no way to get fire except by punk and steel; hence, he had to keep fire covered up in the ashes in the fire-place to light his pipe…When I would bring in the sticks with which to replenish the fire, I would usually bring in two or three buckeyes, which I slipped into the ashes as I covered the wood. The wood would smolder to a coal and the buckeyes would get hot, but they would not explode until the air reached them, when they would explode like the report of a musket, scattering the hulls, ashes and embers all over the house, in the old man's face and against his spectacles. This always happened whenever he uncovered the coals to light his pipe. The good old man never did discover the cause of the explosions.

Because most of the teachers were rigid disciplinarians, they never hesitated to give floggings. Students usually forgave their instructors when it was time for recess and games of "base," "cat," "bull-pen" and "marbles." The very favorite game of the students was called "school butter."

These were the rules:

The sensational occurrence of the session was, however, the chase given some party who, in passing, should holler "school butter!" But such party always took the precaution to be at a safe distance and to have a good start, and stood not upon the order of his going, but went for all that was in him; for to be taken as to roughly handled—soused in some creek, pond or mud-hole. The pursuers were eager and determined, sometimes following for miles and miles, and having but small fear of being punished for neglect of studies. On the contrary, the offence was of so high an order…that sometimes the teacher would join in the race.

ASHEVILLE NORMAL SCHOOL

Asheville Normal School was known by several different names: Asheville Normal, Asheville Normal and Collegiate Institute and Asheville Normal Teacher's College. Located between Asheville and Biltmore Forest, this school opened in 1887. Fourteen faculty members served the female student body. Student "service" was essential for each graduate to integrate herself immediately into the community where she went to teach.

By 1918, 570 women had graduated and applied their lives to service by joining churches, participating in community service and striving to raise their adopted community to "higher ideals." That meant working with the people of Western North Carolina and the Appalachian region. The 1922 *Highlander* yearbook sums up the philosophy of the Asheville Normal and Collegiate Institute: "Faith is the substance of things hoped for; the evidence of things not seen."

BILTMORE FOREST SCHOOL

The Biltmore Forest School, known as the school of "practical forestry," was the first school of forestry in North America. In 1895, Carl A. Schenck came from Germany to manage the forest lands on Biltmore Estate, where he introduced innovative scientific management skills and forestry techniques that proved to be practical. As he went about his work, Schenck was questioned by the young men with whom he associated. Initially, these were sons of wealthy lumber and timber barons. They wanted to know how to have healthy forests, and their interest caused Schenck to start his personal forestry education program in abandoned Biltmore farm buildings.

The curriculum of one year consisted of lectures, plus hands-on field training. Students spent a great deal of time in the forest applying those theories they had learned through classroom lectures. Apparently Schenck's students admired his knowledge and engaging personality, so they learned quickly.

Schenck and his students hosted a festival in November 1908. They gave tours of the various forests and shared their knowledge on planting, logging, seed regeneration and soil composition to university professors, lumbermen, botanists, foresters and furniture manufacturers. Various newspaper editorials praised Schenck for his demonstrations.

Education

All went well until 1909, when the original Biltmore Forest School closed. Reports explain the closing:

> *In 1909, following a disagreement with Vanderbilt, Schenck left his job as estate forester. At this time he was forced to close the doors of the original Biltmore Forest School, as he could no longer operate it on Vanderbilt's property. Schenck continued the school through 1913, though, traveling with his students and operating in various locations.*

One of these sites was in the Brevard vicinity in Transylvania County, North Carolina. Students shopped in a commissary and lived in quarters they called the Hellhole.

BLACK MOUNTAIN COLLEGE

Founded in 1933 by John Andrew Riche, Theodore Dreier and others, Black Mountain College curriculum did not follow what most people consider standard courses. This was definitely a new type of school; it offered an interdisciplinary approach and liberal arts education, following John Dewey's principles, with its core focused on the study of art, creative writing and design. The rewards were great, as noted in one historical report:

> *Operating in a relatively isolated rural location with little budget, Black Mountain College inculcated an informal and collaborative spirit, and over its lifetime attracted a venerable roster of instructors. Some of the innovations, relationships and unexpected connections formed at Black Mountain would prove to have a lasting influence on the postwar American art scene, high culture, and eventually pop culture.*

A few of the success stories from Black Mountain College include Buckminster Fuller and his student, Kenneth Snelson, who designed the first geodesic dome. How did they accomplish this? They did it by improvising with slats taken from the school's backyard. Other greats included Merce Cunningham, who formed his dance company, and John Cage, who staged his first happening.

The Black Mountain College Museum–Arts Center recognized the work of Ray Johnson, called the "most significant unknown artist of the post-war period, a collagist extraordinaire who influenced Pop artists such

as Andy Warhol and Keith Haring." Other luminaries were Josef and Anni Albers, Buckminster Fuller, Merce Cunningham, Robert Rauschenberg, Jacob Lawrence, Robert Motherwell, Franz Kline, M.C. Richards, Nancy Newhall, Francine du Plessix Gray, Harry Callahan and Willem and Elaine Penn.

ASHEVILLE FEMALE COLLEGE

The name continually changed, but the high quality of education remained the same. Begun as the Asheville Female Seminary in 1841 by John Dickson, M.D., and the Reverend Erasmus Rowley, D.D., the college was the first institution of higher education in Western North Carolina. The name changed to Asheville Female College for a short time, and between 1841 and 1866, the name became Holston Conference Female College and, later, back to Asheville Female College. The seven-acre campus saw the growth of buildings and equipment for teaching music, art, elocution, modern languages and physical culture.

Elizabeth Blackwell taught at Asheville Female Seminary, and according to historical reports, Dr. John Dickson took music lessons from Ms. Blackwell. This fostered Blackwell's serious intent and subsequent medical honor: "His music teacher had conceived the idea of studying medicine. He taught her in this science, and later gave her material assistance. She was Elizabeth Blackwell, and afterwards became the first woman doctor who ever received a medical diploma in the United States."

Although she had informally studied medicine by privately reading various texts, she was determined to go to medical school. Rejected by many leading schools, Blackwell applied to Geneva Medical College at Geneva, New York. When the administration asked the medical students already there to decide whether to admit her, they reportedly thought it was only a practical joke. They went along with what they considered a prank and gave their endorsement for her admission.

Elizabeth Blackwell said of her determination: "The idea of winning a doctor's degree gradually assumed the aspect of a great moral struggle, and the moral fight possessed immense attraction for me." Her determination eventually paid off. She graduated first in her class in January 1849, becoming the first woman to graduate from medical school—the first woman doctor of medicine in the modern era.

She went to Paris and took courses in midwifery. Suffering from an eye infection that left her blind in one eye, she had to forego her dream to become a surgeon. In 1853, Blackwell moved to the slums of New York City, desiring to open a dispensary; however, landlords refused her lodging and office space. She did not despair; she bought her own residence and began to see women and children patients in her home.

Even though she never married, she greatly desired a family. In 1854, she adopted an orphan named Kitty. The two remained companions until Elizabeth's death in 1910.

JUDSON COLLEGE

Judson Female College, nearing completion in 1860 in Hendersonville, North Carolina, was intended as a Baptist school for girls. Located at the corner of Fleming Street and Third Avenue, the three-story building costs $18,000. Eliza Corn, the wife of stonemason Drewry Corn, designed the giant stone columns that supported the recessed front porch. Although construction had to cease during the Civil War, the unfinished building did have occupants. Union soldiers, under the command of Major General George W. Stoneman, stabled their horses there and later burned the interior. After the war, all construction was completed, and the name changed to Judson College, and it became coeducational. Lacking necessary funding, Judson College closed in 1892.

COLORED PEOPLE'S SCHOOLS

According to John Preston Arthur in his 1914 book, entitled *History of Western North Carolina*, "Very soon after the war the importance of the education of the colored people, now citizens and voters, was impressed upon the minds of the thinking people of this section." This is what transpired in 1870:

> *The first effort in this direction was the parochial school of the Protestant Episcopal Church, which was taught by Miss A.L. Chapman. After two years she was succeeded by Rev. Mr. Berry, who was both pastor and teacher. This double office has been filled without interruption by educated and influential colored men up to the present time* [1914], *and many heads of families look back with gratitude to the little room on South Main Street*

*and the parochial school building on Valley street, where the rudiments of
an education were obtained, and foundations of character laid, which have
been a blessing to them and their households.*

Through the years, other schools opened over Western North Carolina
for African American children. One structure was described as being "a
fine, substantial building with a tiled roof, with stores and offices on the first
floor and a large lecture hall. On the second floor is a library and reading
room, a parlor and school room and the office of the superintendent." The
lecture hall served many programs, including exhibitions, concerts, Sunday
afternoon song services and various religious services.

Warren Wilson College

Founded in 1894, Warren Wilson College had a unique philosophy,
employing a liberal arts program along with mandatory work for the
instruction and service to the needy. The result was amazing because "this
triad taught students to make connections, solve problems and grasp ideas."
The early creed has continued throughout the years; in fact, it still exists
today at Warren Wilson College. This is the way it works:

*The Academic Program includes hundreds of courses, which continue to
grow in scope and popularity in response to student interest. The Work
Program requires 15 hours of work per week with an assigned work crew,
one of more than a hundred crews that are essential to the daily operation
of the College. In return, students receive a grant of more than $2,400
in credit toward the cost of tuition. The Service Program requires at least
100 hours of service during a student's four years, with 25 of those hours
focused on one issue or group. Service projects can take students into the
community, across the country, or even abroad.*

Literature explains the importance of student involvement: "Ambitious,
idealistic, independent—Warren Wilson students are passionate about social
justice and believe in taking risks. They're hard workers and loyal friends.
Always questing and looking for new challenges, they are a community of
self-made individuals who thrive on inquiry and change."

Charles D. Owen High School

Named in honor of the founder of the famous Beacon Blanket Manufacturing Company, Charles D. Owen High School was located in Swannanoa. Students called their mascot Warhorses, which was a combination of the favorite names from the two merging schools, Swannanoa and Black Mountain. The early Swannanoa High School had "war" as its mascot's name, and the Black Mountain High School's mascot was called "dark horse." These two schools consolidated in 1956 to become the Charles D. Owen High School.

This school produced several famous athletes, including Brad Daugherty, who played at the University of North Carolina at Chapel Hill and also with the Cleveland Cavaliers. Brad Johnson, who was quarterback of Super Bowl champion Tampa Bay Buccaneers, graduated from Owen High School. Roy Williams went on to coach basketball at UNC–Chapel Hill from his position of basketball and golf coach at Charles D. Owen High School from 1973 to 1978.

Not all celebrities were athletes. Well-known mystery author Patricia Cornwell graduated from the high school.

Chapter 6
Believe It or Not

ARTIFACTS AND LEGENDS

Before the white man arrived in the Western North Carolina mountains, this area was home to the Cherokee Indians. Lynn Setzer, correspondent of the *Raleigh News and Record*, was intrigued by this history and set out one weekend to explore the area. The following are legends based on different areas of Jackson County:

> *Judaculla was a fierce, slant-eyes giant who ruled the Balsam Mountains. His mother was a flashing comet; his daddy was the thunder. His bow was the arc of heaven, his arrows were shafts of lightning. Legend held that he could drink streams dry with a single gulp, that he could step from one mountain to the next. His voice made the heavens rumble, and his face was so ugly that men turned from him in horror...Supposedly, Judaculla lived in a lair on the southwestern slope of Richland Balsam Mountain, the highest point on the Blue Ridge Parkway. Near Richland Balsam, a rock outcropping stretches into the sky. Called Devil's Courthouse, this rocky ledge is home to a superb view—and a cave where Judaculla held court...The etchings on Judaculla Rock are clearly man-made, and no one has been able to explain what they mean or why they're there...But if Judaculla were everything that the legend said he was—even if he were only half of what legend said he was—isn't it possible that he left those marks when he leapt down from his lair and thrust his seven fingers into the soapstone? Soapstone isn't the hardest of rock; Richland Balsam is a high mountain and Judaculla was a large guy.*

Next, researcher Setzer looked for the area where Judaculla's counterpart, Spear-finger, lived and reported this unusual legend:

The Cherokee name for Whiteside Mountain is Sanigilagi, meaning "the place where they took it out." Originally this mountain was part of a great rock bridge that extended southward down the Blue Ridge Escarpment. A terrifying she-monster lived there, and her favorite food was human livers. Her skin was rock hard and she had, on her right hand, a bony forefinger that she used to stab her victims. Finally, the medicine men throughout the nation held a great council to discuss how to rid themselves of this she-monster. As the warriors assembled in the valley, the medicine men took their place along the summits of mountains. Then they prayed, asked the Great Spirit to bring out the monster. Soon the prayer was answered: a lightning bolt struck the rock bridge, shattering it and exposing the monster. The warriors swarmed in to kill her.

That weekend in the mountains did not exactly make Lynn Setzer a believer in myths. But who knows what is truth and what is legend?

THE WEDDING OF THE DECADE

On April 29, 1924, Cornelia Stuyvesant Vanderbilt, the only child of George and Edith Vanderbilt, was married to British diplomat John Francis Amherst Cecil in All Souls Church in Biltmore Village.

Earlier that week, Cornelia Vanderbilt had met her bridesmaids at the train station. Those same eight bridesmaids, followed by the maid of honor and two flower girls, entered the church to German composer Richard Wagner's "Wedding March." Cornelia's mother gave her in marriage. Cornelia's father had passed away ten years earlier.

The bride's gown was satin with long sleeves. She wore white satin slippers. Her veil, four yards long, was of white tulle and rose-point lace, decorated with orange blossoms. Lilies of the valley and orchids composed the bridal bouquet.

An old English custom completed the formal ceremony, when forty-four children dressed in white, formed a double aisle on the church lawn. The wedding party passed under the arch of crossed branches of spring blossoms.

Following the nuptials, approximately one thousand guests attended the reception and wedding breakfast at Biltmore Estate. Newspaper documentation gives the details:

> *Two orchestras played at intervals, and dancing was taken part in by many*
> *of the guests before the wedding breakfast…As the members of the bridal*
> *party placed themselves around the table, the orchestra struck up "God Save*
> *the King," followed by the "Star-Spangled Banner." As the latter was being*
> *played, Mrs. Cecil turned to face the American flag, which was draped over*
> *an archway and crossed with the British Union Jack, emblematic of the*
> *union of the two nations.*

Unfortunately, the lavish wedding did not guarantee happiness for the couple. Ten years after their marriage, Cornelia divorced her husband and left him and her two children to spend her life in Europe. The April 9, 1934 edition of *Time* magazine reported the divorce in this manner:

> *Sued for Divorce. John Francis Amhert Cecil, one time secretary of the*
> *British Embassy at Washington; by Mrs. Cornelia Vanderbilt Cecil, only*
> *daughter of the late George Washington Vanderbilt; in Paris. By her father's*
> *will which left her approximately $50,000,000, Mrs. Cecil was required*
> *to live at least six months of the year at "Biltmore House," the huge French*
> *Renaissance chateau he built near Asheville, N.C. Her marriage, ten years*
> *ago this month, was an international occasion. Following it, Mr. Cecil gave*
> *up his diplomatic career and became manager of his wife's estate.*

Still, an uncovered history is the last name Cornelia chose as her identity while she lived in Europe.

MINUTES OF THE COURT

According to one historian, there was more than one way to obtain a divorce, as illustrated by several Minutes of the Court. "July 1792: 'A bill of divorce from Ruth Edwards to her husband, John Edwards was proved in open court by Philip Hoodenpile, Esq., a subscribing witness heretofore—ordered to be registered.'"

While this homely method of untying the inconvenient matrimonial knot does not begin to compare with the modern solemn performances to accomplish the same end, it has the merit of being far more honest and direct—and, doubtless, was as effectual. Perhaps the parties, in the absence of any other known provisions of law of precedents, recalled the old Misaic statute, that when a man desires to get rid of an undesirable wife, "let him

"Ground for Divorce."

write her a bill of divorcement, and give it in her hand and send her out of his house."

A very early bilingual notice in English and Cherokee stated that William McConnell would no longer pay the debts of his wife, Delilah McConnell, as she had left him. "October 1793: 'Ordered by court that Thomas Hopper, upon his own motion, have a certificate from the clerk, certifying that his right ear was bit off by Philip Williams in a fight between said Hooper and Williams. Certificates issue.'"

After said order was issued, Hooper, knowing that the punishment for certain crimes—perjury and forgery, was by cutting off a portion of the ear of the offender. This was called "cropping," Thomas Hopper responded to this punishment by saying, "We can well understand why."

"A Divorce Cure."

Notice: "I Hereby Forwarn All Persons Against Crediting My Wife, Delilah McConnell."

The World's Largest Ten Commandments

The largest set of the Ten Commandments is located about eighteen miles west of Murphy, North Carolina, nestled in the Great Smoky Mountains. The hidden history behind this attraction began in the early 1900s, when Ambrose Jewssup Tomlinson arrived in the area to distribute religious tracts to the Western North Carolina mountain people. According to historians, this is what transpired:

> *Tomlinson and a few followers decided to form a new church hoping to find the true way of Christ. Before the group met, Tomlinson hiked up a nearby mountain to pray. He came back saying that God had revealed to him what kind of church it should be. Thus, the beginnings of the Church of God of Prophecy, a church that now has more than 700,000 members in 115 countries. Tomlinson decided that one of the missions of his church would be to mark sacred spots because Jacob in the Old Testament had marked the spot where he received his vision of a ladder leading from earth to Heaven. Where his own church was formed was the first place he decided to mark. The church bought 210 acres of land, including the mountain where Tomlinson had gone to pray for guidance. There Tomlinson planned to create a holy place and name it Fields of the Wood.*

He began his project by creating the world's largest Ten Commandments. Letters, 4 feet wide and 5 feet tall, became individual letters for each commandment. Other Believe It or Not markers were dedicated through the years: the world's largest altar, which is 80 feet long; the largest New Testament; an open concrete Bible, 30 feet tall by 50 feet wide; the world's largest cross, 115 feet wide and 150 feet long, surrounded by the flags of eighty-six nations in which the church exists; a replica of Christ's tomb; and a baptismal pool.

Before Tomlinson died in 1943, he was able to view the commandments spelled out in lime. Two years after his death, the concrete was painted white to complete this unusual project.

Pure Hogwash?

The Brown Mountain Lights were first viewed by Cherokee and Catawba Indians as early as 1200. The unusual lights were documented in 1913, when

a reporter for the *Charlotte Observer* explored the mystery. Then, the United States government investigated a total of three times. The U.S. Weather Service and the Smithsonian also joined in the study. By 1922, a geological survey conducted by George Mansfield, and his official report offered the following explanation for the lights:

> *In his official report, titled* Circular 646, *he stated the lights were 47% auto headlights, 33% locomotive lights, 10% stationary lights, and 10% brush fires. Almost everyone clearly saw the report as pure hogwash. The lights had been seen long before autos and locomotives. Plus, in 1916, a great flood wiped out transportation routes. There were no trains or autos in the area for more than a week. However, the lights continued to be seen.*

Artists, writers and paranormal teams have been fascinated by Brown Mountain Lights. In the Andy Anderson novel *Kill One, Kill Two*, the lights appear before a murder occurs. North Carolina authors John Harden, Nancy Roberts and John Parris have all included the phenomenon in their works. In the early 1960s, Tommy Faile's hit bluegrass song "Brown Mount Light" gained popularity. More recently, the lights were featured in a May 9, 1999 episode of *The X-Files*, a show entitled "Field Trip."

Are the lights paranormal? LEMUR, a paranormal research group in Asheville, North Carolina, is currently investigating the Brown Mountain Lights. Maybe that team will be able to respond to the "Pure Hogwash" theory.

TASTELESS CHILL TONIC AND LAXATIVE BROMO QUININE

While Edwin W. Grove's fulfilled dream of building the Grove Park Inn proved, indeed, tasteful, folks would testify that his invention of Tasteless Chill Tonic was definitely not tasteless. It was created as a preventative and relief for malaria's chills and fever—called the scourge of the south—and some attest that the medicine did taste better than quinine. This chill tonic was given to every British soldier who was headed to mosquito-infested lands. Two tablespoonfuls, morning and evening, were taken for eight weeks, and sometimes for the entire malarial season.

According to reports, by 1890, "more bottles of Grove's Tasteless Chill Tonic were sold than bottles of Coca-Cola." The tonic was given to both children and adults. So what exactly went into the mixing of this popular elixir?

Quinine, cinchonine and cinchonidine are alkaloids extracted from powered cinchona bark. These active ingredients were in a crystallized form. To make the intensely bitter taste more palatable, sugar syrup and lemon flavorings were added. The tonic had to be shaken and quickly swallowed before the active ingredients settled back onto the bottom of the bottle. "I had a little drug business, just barely making a living, when I got up a real invention, tasteless quinine," Grove reminisced. "As a poor man and a poor boy, I conceived the idea that whoever could produce a tasteless chill tonic, his fortune was made."

While Tasteless Chill Tonic sold well, Laxative Bromo Quinine, the world's first cold tablets, kept the drug company afloat. This is how it was advertised:

Grove's Laxative Bromo Quinine was a treatment for "La Gripps," which was the early 20th century term for an influenza epidemic. Each tablet contained two grains of phenacetin and was also effective for colds and headaches. Grove's son-in-law invented the machine that created, sorted and counted these cold tablets. From the bottom of the box: "An excellent remedy for Coughs and Colds. Relieves the Cough and also the feverish conditions and Headache, which are usually associated with colds. The second or third dose will move the bowels well within 8 or 10 hours, when the cold will be relieved…Grove was understandable worried about copycats and combated them by educating patrons." Imitators use the names as nearly like Laxative Bromo Quinine as they dare, but they cannot use the signature of E. W. Grove which appears on every box of the genuine. BE SURE IT IS LAXATIVE BROMO QUININE.

In 1957, Grove Laboratories became a division of Bristol-Myers Company, which continued to use the familiar orange packaging, with the original "laughing baby" trademark. One interesting blog mentions another hidden history concerning Tasteless Chill Tonic:

Hi, my family used it because we had pollywogs (and other "things") in our well water. We didn't have to take it year 'round, mainly in the spring, when pollywogs were abundant in our water supply. The tonic was by no means tasteless. It had an antiseptic, quinine taste to it, and was very effective in treating parasites and bacteria. It was more cost effective and medically effective to take the tonic than to treat the water. Besides, we didn't know much about that and a good tonic was easy to come by.

FROM PROSPERITY TO DEPRESSION ERA AND BACK TO THE GOOD LIFE

That day in 1784, when pioneer William Davidson and his family moved all their belongings through the Blue Ridge Mountains to live in what is now known as Buncombe County, they become the first settlers in the area. They established their home on Christian Creek in the Swannanoa Valley area known as Eden Land. More and more families came, so on December 5, 1791, Colonel David Vance and William Davidson established Buncombe County. What is now Pack Square contained a small log courthouse. Forty half-acre lots sold for $2.50 each. By 1797, the area was incorporated, and it was named Asheville in honor of Governor Samuel Ashe. Asheville grew quickly. In 1851, the Asheville and Greenville Plank Road brought many wealthy people to town on four- and six-horse stages to enjoy the health spas the town offered.

Not all remained peaceful, calm and serene. During the Civil War, Asheville became a vital Confederate military center. Soldiers carried a flag made from the silk dresses of the town belles when they marched on

Court Square–Vance Monument, Courthouse, City Hall Palmetto Building and Asheville Library.

April 18, 1861. The late 1800s brought trains, a new railroad industry and affluence. Then, in the early 1900s, Asheville's economic growth skyrocketed with assembly grounds, an opera house, a convention hall and the Asheville Board of Trade, developed in 1900 by the chamber of commerce, which labeled Asheville one of "the leading convention cities in the country." Luxury hotels and inns sprang up everywhere.

Everything was going great until the Great Depression of the early 1930s caused Asheville to spiral downward, both economically and psychologically. Asheville struggled. Plans were made for two projects that would add some day to Asheville's reputation as a tourist destination throughout the world. Under the Franklin D. Roosevelt administration, construction of the Great Smoky Mountains National Park and Blue Ridge Parkway gave much-needed employment to members of the Civilian Conservation Corps (CCC). An interesting aside to this is the fact that, after the stock market crash in 1929, many cities defaulted on Depression-era bonds and liabilities. Asheville chose not to default; consequently, city fathers chose this option:

> *They decided to pay back every dime of the city's debts. Many generations paid the price for this decision until the slate was cleared in 1977. Until that year, Asheville had no money to invest in "urban renewal" so popular during the 1950s and 1960s in other cities. The commitment to debt repayment saved from the wrecking ball dozens of Art Deco buildings erected during the city's boom decades earlier.*

According to one report, "Asheville retained the highest per capita debt of any city in the country, yet founding fathers vowed to pay every cent the city owed. Creditors received their payments and Asheville struggled until 1977—the year financial shackles were loosed and all bonds were paid."

WORLD WAR II DETENTION OF DIPLOMATS AND FAMILIES

After the bombing of Pearl Harbor on December 7, 1941, by the Japanese military, diplomats were stranded in enemy countries. What happened to these people is a true Believe It or Not story, involving protocol that urged "above average treatment of such diplomats and their dependents while awaiting repatriation, as well as provisions to ensure their safety."

In the U.S., these diplomats, businessmen and families were housed inland for short periods of time at Montreat Assembly Inn. These diplomats and families began being transferred on December 19, 1941. Everyday operations of the facility was handled by the Immigration & Naturalization Service. One present-day author described the treatment afforded these diplomats and families as provided in "a regal manner...the United States hope its diplomatic officials would receive the same treatment."

How did this confinement work? According to records, the Montreat Retreat Association agreed to house these civilians until April 1, 1942—and no later—because the Presbyterian Church in the United States had planned a meeting in Montreat for May 1943. So, "on October 29, 1942, 264 diplomats, wives and children were transported to Montreat." What happened next?

The German contingent was housed on the two lower floors of Assembly Inn, with the Japanese women and children primarily on the upper third floor. The Montreat Retreat Association placed a Japanese language New Testament or German-language Bible in the appropriate hotel rooms. The diplomats and dependents could exercise in the parking areas of Assembly Inn, and roam territory from the hotel to the lake, between the dam and the upper concrete bridge at the head of the lake. At Christmas time, presents were provided to the Japanese and German children. Reportedly on Christmas Eve 1942, young people from Black Mountain gathered at the lake bridge and joined in singing Christmas carols with the diplomatic families—singing "Joy to the World" and "O Holy Night."

OBSESSION AND ILLNESS OR FEMINIST ICON?

Zelda Sayre Fitzgerald, diagnosed with schizophrenia, entered the Highland Mental Hospital in Asheville in 1936. Her husband, F. Scott Fitzgerald wrote to friends:

Zelda now claims to be in direct contact with Christ, William the Conqueror, Mary Stuart, Apollo and all the stock paraphernalia of insane-asylum jokes...For what she has really suffered, there is never a sober night that I do not pay a stark tribute of an hour to her in the darkness. In an odd way, perhaps incredible to you, she was always my child (it was not

reciprocal as it often is in marriages)...I was her great reality, often the only liaison agent who could make the world tangible to her.

Zelda remained at Highland Mental Hospital, and Scott left Asheville for Hollywood in June 1937. He returned to Asheville in 1938 and took Zelda on a trip to Cuba. This, according to historians, is what happened: "The trip was a disaster even by their standards: Scott was beaten up when he tried to stop a cockfight and returned to the United States so intoxicated and exhausted that he was hospitalized. The Fitzgeralds never saw each other again."

Zelda's mental health seemed to be better, so, nearing the age of forty, she was released from the Highland in March 1940, four years after she had been admitted. Ironically, however, when Scott died on December 21, 1940, Zelda was not well enough to attend his funeral. She started writing her own novel, *Caesar's Things*. Her mental health declined once more, and she reentered Highland Hospital. Unfortunately, she did not get better, and she never finished the novel.

A fire broke out in the hospital kitchen on the night of March 10, 1948. Blazes quickly spread to all floors of the hospital and even to the wooden fire escapes. Zelda and eight other women died in that fire. After her death, interest in her life increased. According to one critic: "After a life as an emblem of the Jazz Age, Roaring Twenties, and Lost Generation, Zelda Fitzgerald posthumously found a new role. After a popular 1970 biography portrayed her as a victim of an overbearing husband, she became a feminist icon."

Perhaps daughter Scottie's reflection on her mother's life is entirely accurate: "I think (short of documentary evidence to the contrary) that if people are not crazy, they get themselves out of crazy situations, so I have never been able to buy the notion that it was my father's drinking which led her to the sanitarium. Nor do I think she led him to the drinking."

So, was Zelda Fitzgerald obsessed, ill or a feminist icon? Perhaps it was a strange combination of all three!

A Picture's Worth a Thousand Words

Pamphlet No. 92 distributed by the National Child Labor Committee, Inc.—105 East Twenty-second Street, New York City—reveals accounts of investigations made in the cotton mills of North and South Carolina. The North Carolina Child Labor Law sets out the following stipulations for child labor:

**Age Limit for Employment in Factories, 13 Years*
**In Apprenticeship Capacity, 12 years*
**Age Limit for Night Work, 14 years*
**Hours of Labor for Children Under 18, 66 hours per week*
**Employment Certificates, Written Statement of Parent or Guardian*
**Employers Must "Knowingly and Willfully" Violate this Law Before They Can Be Convicted.*
**No Factory Inspection. Commissioner of Labor has no Authority to Enter a Factory.*
**No Prosecutions Under the Law*

In the early part of the twentieth century, photographer Lewis H. Hine was hired by the National Child Labor Committee to investigate child labor conditions and to record with his camera what he found. One of the mills that Hine visited was Whitnel Cotton Manufacturing Company in Whitnel, North Carolina. Hine's photograph of the mill running at night carries this narrative, "Out of 50 employees there, 10 were about 12 years old, and some surely under that." One of the spinners in Whitnel Mill was fifty-one inches high. She had been in the mill one year, some days at night. She ran

Whitnel Cotton Manufacturing Company, running at night.

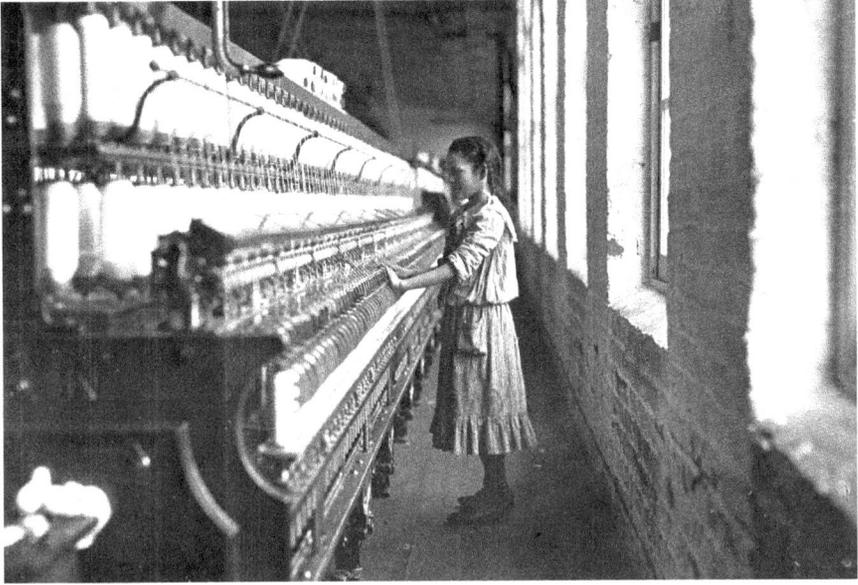

A fifty-one-inch-tall spinner at the mill.

four sides and made forty-eight cents a day. When asked how old she was, she hesitated and then said, "I don't remember." Then confidentially, "I'm not old enough to work, but I do just the same." Children went to work at 6:00 p.m. for their night shift and did not come out again until 6:00 a.m. When they went home the next morning, they were sometimes drenched by a heavy, cold rain and had few or no wraps. Two of the smaller girls, with three other sisters, worked on the night shift, according to one report, "to support a big lazy father who complains he is not well enough to work. He loafs around the country store." Many doffers in Whitnel Manufacturing Company were also underage.

Some of the smaller "hands" on the night shift waited for the whistle to blow at Whitnel, North Carolina, cotton mill. According to photographer Hine, "The smallest boy and girl were about 50 inches high. One of the medium sized boys has doffed 4 years—some at night. Got 60 cents a night. Smallest girl looked 10 years old. Been in mill 2 years. 1/2 year at night. Runs 8 sides part of the time."

> The small children on the day shift number nearly as many as those on the night shift. Often, everyone in a family, except the mother, works in the mill. The father earns $1.00 a day. The smallest girl, Annie Philips, been

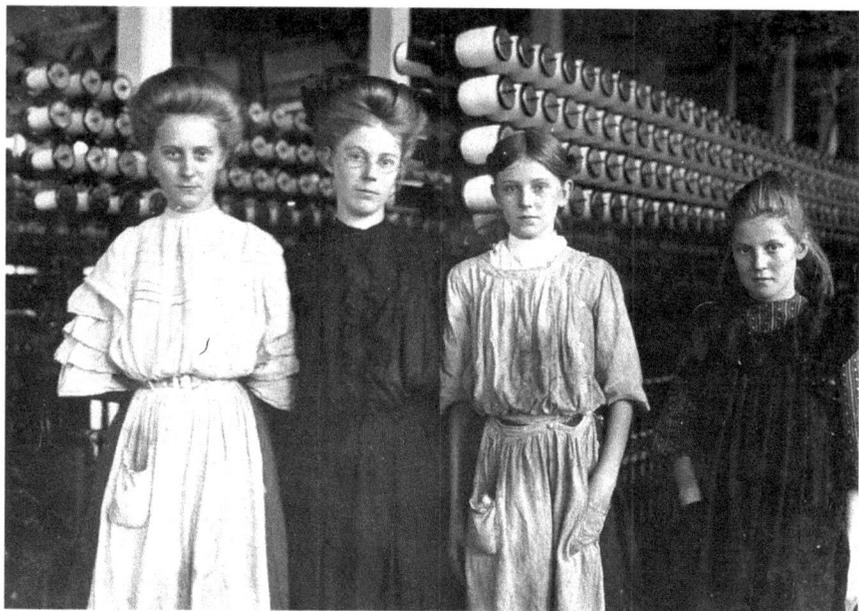

Everyone in this family, except the mother, works in the mill.

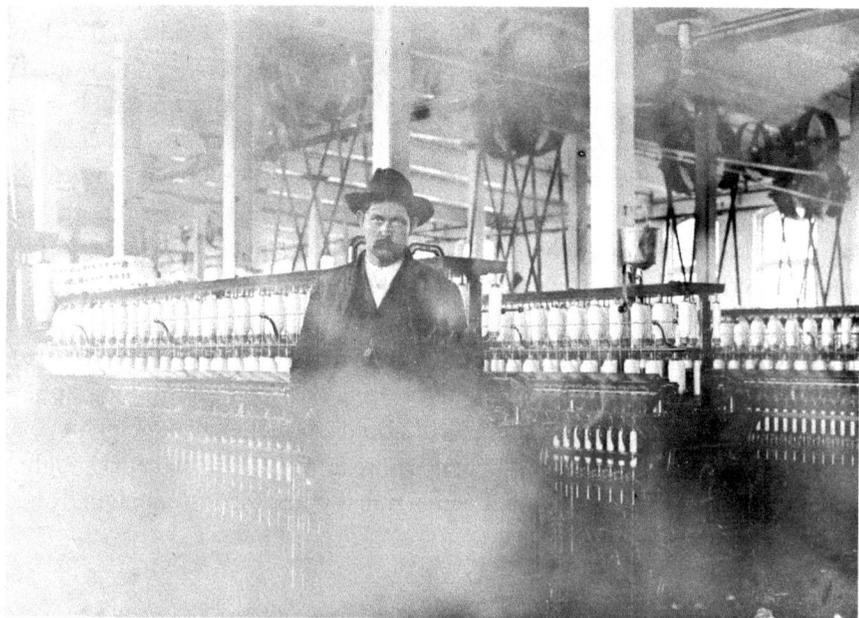

T.A. Wright, superintendant of the Whitnel mill.

there only a few months, earns nearly a dollar a day. Next in size, Clara Phillips, 13 years old, been there three or four years, earns over a dollar a day. Next, Daisy Philips. Next, Mary Philips. A dollar a day each. The oldest is married and her husband is in the mill.

T.A. Wright, superintendant of Whitnel Cotton Manufacturing Company, described by photographer Hine as "a typical boss, except that he was less gruff and suspicious than most," had been at the mill for eighteen years. Wright was reported as saying, "Parents are responsible for so many children in the mills. Father loafs just as soon as children get old enough to work."

SHELTON LAUREL MASSACRE

During the Civil War, the government promised rations to families in the Appalachian region; however, essential staples did not arrive. Salt was especially needed—for a number of reasons:

It was used to preserve meats and butter and for tanning hides. Its availability could mean the difference between survival and starvation. Large quantities were necessary. It took 50 pounds of salt to preserve one 500-pound hog. The South had little access to salt. That held doubly true for the isolated mountains. The winter of 1862–63 was especially harsh. As circumstances worsened, concern changed to frustration. Eventually desperation turned the winter violent.

Residents of Madison and Yancey Counties were divided in their loyalties to the north or south. Most men were away from home, fighting the war, and rations became practically nonexistent. Resident of Madison County— mostly Union sympathizers—decided to act. In 1862, a group left for Marshall, North Carolina, stealing what they needed and destroying what they did not want. One of the residences they hit was the home of Colonel Lawrence Allen, commander of the Sixty-fourth North Carolina Infantry, away in Virginia at the time. The following transpired, according to one historian:

The raiding band of marauders terrorized the small family, stealing food and supplies. Marshall's citizens were outraged. The 64th set out to apprehend the men in the Shelton Laurel Valley. Most of the raiders fled.

On January 19, 1863, fifteen men, aged 15 to 60 were rounded up. It was later determined only five of the fifteen were involved in the Marshall raid. The men were arrested and marched off. Somewhere along the way two of the men escaped. The remainder were then executed by firing squad. The bodies were then placed in shallow graves. Discovering the horrific results of the massacre, Shelton Laurel residents removed their executed friends and relatives from the hastily constructed grave. They were eventually buried together in a single grave near the very location of their execution. Today, a granite marker memorializes the site.

The incident earned the nickname Bloody Madison, and one local resident said, "I know families in the county that are just as proud of being descended from the ones who killed those men as the people out here are of those who survived."

Entertainment and Celebrations

Whittling the Time Away

Whittling wood is an art form that dates back to the cavemen who made weapons, cooking utensils and even carts. The dictionary defines "whittling" as "cutting small bits or pare shavings from a piece of wood. To fashion or shape in this way; whittle a toy boat or other small objects." This technical definition fails to recall the relaxation, pleasure and creativity that whittling has brought to folks in the mountains of Western North Carolina. One researcher has noted, "While whittling wood seemingly led to further technological advances in society, it carries a personal meaning for those who have chosen it as a hobby. It is believed to be a meditative activity, placing the whittler and his wood in a place of contentment. It provides peace and a feeling of oneness with man and his environment."

The favorite wood for whittling was balsa wood or basswood, which were soft enough for carving, yet strong enough to hold the details. Pine or ash was also used. Some liked to whittle figures of fish, ducks and birds, while others prefer making bottle stoppers or caricatures. Finished details were course, rather than refined. Uniform color proved best. A hand-held pocket knife or special whittling knife was used to produce religious idols or statues, while others had a more functional use. While "carving" and "whittling" have sometimes been used interchangeably, they are very different, says one expert, because "carving can employ the use of chisels, gouges, and a mallet, while whittling is only done with the use of a knife."

While whittling may be a hobby for some, it can become a business for others; nevertheless, the experience is rewarding for all.

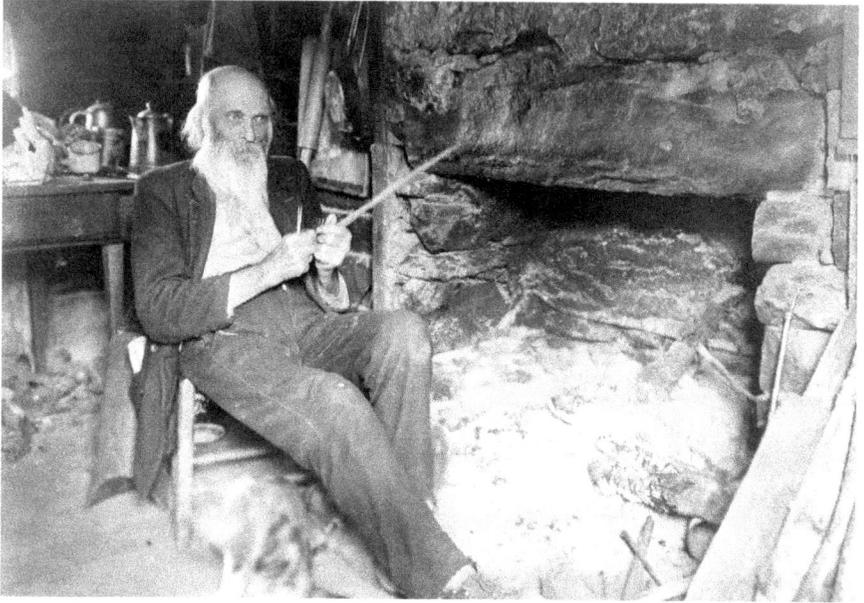

A mountaineer whittling.

DARE TO BE SQUARE

The French produced a dance form that they called the quadrille, which is today considered to be the forerunner of the square dance. In the 1950s, square dance callers decided to try something new. They created more interest in the movements by moving everyone at the same time. The basic calls grew from sixteen basics to twenty, and then to thirty-two. A square dance caller found that the electronic amplifier allowed him to be heard by larger crowds, and he did not have to resort to shouting or to using a megaphone. Live music from fiddle players accompanied the calls.

A Saturday night at a VFW, grange hall or school gym attracted men and women who were interested in square dancing to old-time music. According to one historian, "For many people, old-time music and dance fit right in with other folk music tastes, back-to-the land ideals and interest in the old-time ways. Old-time music...went hand-in-hand with homemade bread, food co-ops, and thoughts of log cabins and living off the land."

One multi-talented mountain man, Doc Watson, had lost all of his vision before his first birthday. Because "listening" became extremely important,

The Junior Square Dance Team from Waynesville.

The dancing area at the Mountain Music Festival.

Miss Margot Mayo and Miss Deska of American Square Dance Group of New York City and Bascom Lamar Lunsford, director of the Mountain Music Festival.

Doc listened to the harmonica, Victrola phonographs, blues guitar players, singers, and fiddlers. Doc eventually learned to play the banjo and the guitar. He also became a piano tuner. Then, he was needed to play regular gigs for a square dance band at the American Legion in Boone, so he improvised.

The square dancers preferred to dance to fiddle tunes, but the band did not always have a fiddler. Watson had to learn how to play fiddle tunes on his guitar. Because other guitar players were not playing fiddle tune melodies, he used creativity and invented his own way to play them. He spent hours practicing, learning to play the melodies by using a flat pick, going up and down on the guitar strings. He became very good and could play lots of notes, fast and clean.

I Love Mountain Music

Many people will vow that mountain music is good for the soul. Whether it was an individual playing his violin by a solitary window of his home or performing at the Mountain Music Festival with fiddle and banjo for hundreds of people, folk musicians were respected, honored and loved. Music lovers came from near and far to pat their feet, clap their hands and allow the music to drift into their spirits.

Whether it was a performing duo with guitars or a young fiddle player paired with a man strumming his guitar, the crowd went wild. Four musicians performing at the same time was sometimes even better.

Musicians with guitars.

Four musicians performing.

DARK OF THE MOON

The Asheville Community Theatre, founded in 1946, produced the first amateur production of the Appalachian drama *Dark of the Moon*. A stack of mattresses were used to break the actresses' fall when they leapt off the mountain peak of the witches' lair. Characters are named Conjur Man, Conjur Woman, Uncle Smelicue, Burt Dinwitty, Preacher Haggler, Dark Witch and Fair Witch.

According to theater critic, Alvin Klein,

> *Mention* Dark of the Moon, *written by cousins Howard Richardson and William Berney, and the memories of many theatergoers are likely to hark back to college or high school productions of the hillbilly tale about the witch-boy who begs to be made human after having his way with the lusty mortal Barbara Allen atop Bald Mountain. The hitch is that she must remain faithful to him for a year.*

The dialogue includes lines like, "howdy, preacher," "howdy brethren," "I reckon" and the famous witch-boy plea, "Don't be skeered, Barbara Allen."

I love you. I'm human." Critic Klein felt that maybe the uncertain tone of the work comes as a result of the playwrights writing the drama as a satiric response to a bad play. However, Klein can see traces of "eternal fidelity, transcendent love, and mob psychology."

As unconventional as *Dark of the Moon* must have been to the 1946 audience, the weirdness did not keep Charlton Heston and his wife, Lydia Clarke, away. They soon took over the Asheville Community Theatre. Later, Heston starred in movies like *Ruby Gentry* (1952), *The Far Horizons* (1955) and Cecil B. DeMille's *The Ten Commandments* (1956).

WHERE THE SPECKLED BEAUTIES PLAY

Mountain trout streams provided the angler with both entertainment and food for his table. Perhaps early Native Americans discovered that trout fishing was a peaceful sport that also produced a hearty meal. Through the years, trout fishermen have combined leisure with procuring food for their families.

Brook trout fishing.

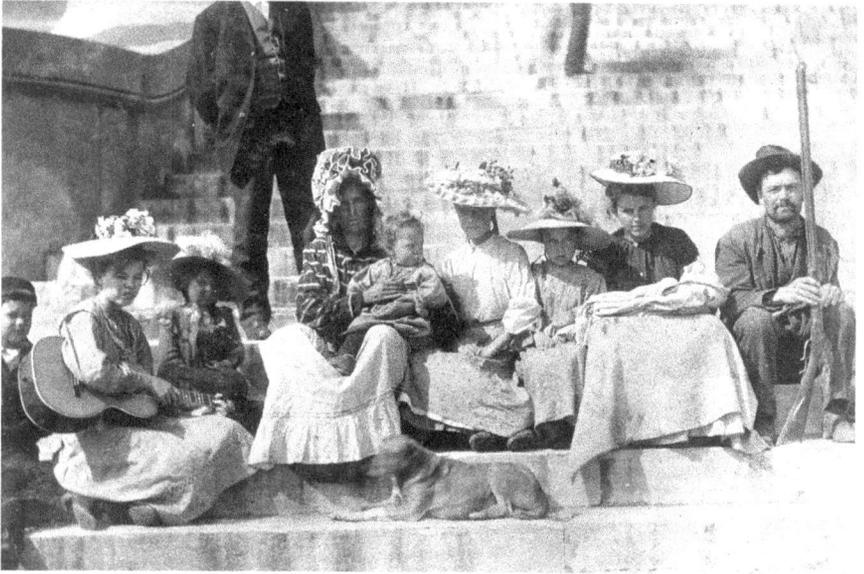

Reunion at Scaly Gap.

The dropped
stitch.

SIMPLE MOUNTAIN PLEASURES

One of the most popular forms of entertainment was the traditional family gathering. Folks, including children, would dress in their best attire, pack a bountiful picnic lunch, take their musical instruments and head for a quiet, scenic mountain destination for a Sunday afternoon get-together. The more adventurous members hiked the Old Mount Mitchell Trail to pick wildflowers. There was always plenty of food, especially veggies from the garden.

Or Sunday morning might be spent sitting in the doorway of a one-room cabin, knitting, gazing at the lakes and mountains or simply reflecting on the beauty of the day. Since children had few toys, a little girl might sit on her porch steps, holding a large chicken. Another form of autumn mountain entertainment involved apple-picking time, when apples would be preserved for the winter or used to make delicious apple dumplings.

PLAYING CHUNKY: A CHEROKEE LEGEND

In April 1972, Mrs. Mary Chiloskey recorded legends of the Cherokee Nation for the Southern Highlands Research Center Oral History Collection. Her story went like this:

In this particular town there were eight boys who played chunky every afternoon after they had finished their work. You just had to have a stick. Now, of course, a boy who really played a great deal, usually got him a stick about so long and about so wide while it was green, stuck it in the fire, rubbed off the end a little bit to make it a little pointed, and he would play with that.

To win this game, you just had to hit that chunky stone dead center with your stick as it was rolling. It would flop over, and you had won the game. No young boy ever had a chunky stone. They were too valuable. One old man at the council house had one that was handed down by his father. Eight little boys would come and ask him to roll the chunky stone, and they would go running along beside it, throwing their stick trying to make it flop over.

When summertime would come on, problems arose at home. This group played later and later and later as the days got longer. Mothers complained about their boys missing their evening meal. One wise woman told the mothers what to do. She said, "Tomorrow, call them loud and clear. If he doesn't come in, go ahead and serve the food. Leave the pot by the fire and put broken stone in it. That will break him."

So, the next day, when all the suppers were ready, mothers went to the doors to call the boys, but they kept on playing. The old man rolled the chunky stone one more time. Then the boys ran into their houses and discovered nothing but an old chunky stone in the pot. They all ran back outside running around the council house. Well, after about the third time around, their feet weren't even touching the ground. One mother went outside; by the time the moon had come up just a little bit, there was a little bit of light showing. She looked. There her son just sort of sailing through the air just above her head. Well, she jumped up and grabbed him by both heels and pulled him down with all that determination right down into the ground. She just buried him right in the ground. The only thing she could do was just stand there and let the salty tears fall to the ground.

One by one out of the other cabins came the other mothers after awhile, and they came and joined her, their children, the seven, circling up into the sky. Day after day they came and wept, and the salty tears fell. after many days, one mother noticed a little green shoot coming up right straight, rather needle like. Each day it grew higher and higher; after awhile it put out branches, and on the end of those branches came little green needle-like things, growing up straight, straight, straight.

African American boy holding two chickens, which seems to indicate cockfight gambling.

Children of the soil.

Now, the white man will tell you that that's the "pine" tree; pine meaning to be sad or be sorrowful. But of course, any Cherokee can tell you that that's just the little boy whose mother buried him, trying to reach the sky to be with his playmates. They are up there, the seven of them, and the white

A group of boys sitting in front of a fence.

man again will tell you that they are called the Pleiades. With your naked eye on a clear night, you can see six of them, but you have to have a little help to see the seventh. That was the youngest little boy; he didn't want to stay out that long to begin with. He certainly didn't want to go back out after he didn't get any supper, but you know how it is when you play with big boys.

Not only did little Cherokee boys enjoy their games, children in the mountains always invented some type of play or entertainment that kept them happy.

TAKE ME OUT TO THE BALLGAME!

Western North Carolina has a long history in the game of baseball. In 1866, when soldiers returned home from the Civil War, they brought with them the game. At first, the sport was not far removed from sandlot ball, because games at Carrier's Track in Asheville saw the "We-Un's" versus the "You-Un's."

In 1897, professional baseball came to the mountains. The Moonshiners played for a very short time before disbanding. But, you couldn't keep a good game down! About 1909, pro baseball returned with the Redbirds, which became the Mountaineers a year later. Finally, by 1910, the team was known

as the Tourists, and they earned the title of playing the fastest professional game on record, as described by one sport enthusiast.

> *The Tourists played a 31-minute "speed-up" game on August 31, 1916. (Why so fast? The opponent, Winston-Salem, needed to catch a train out of town, so both teams agreed to the fast play.) The batboy in that game was 15-year-old Thomas Wolfe, who would later achieve fame as an author known for works like* You Can't Go Home Again.

An additional hidden baseball history concerns the fact that, in 1924, McCormick Field was named for bacteriologist Dr. Lewis McCormick, leader of the "Swat That Fly" movement that encouraged people to kill common house flies in order to prevent the spread of diseases. Quite possibly, this was the only ballpark named for a bacteriologist. Also, in 1924, the Asheville team name had changed to the Skylanders. They saw some fierce competition that year.

One of the first games at McCormick Field came on April 3, 1924, when the barnstorming Detroit Tigers came through town to take on the Asheville Skylanders of the Piedmont League. The Tigers won, 18–14; Heinie Manush hit the first homer in ballpark history, and Hall of Famer Ty Cobb contributed a round-tripper as well.

A crowd takes in a ballgame.

Other major league teams barnstormed through Asheville after spring training. Jackie Robinson became the first black to play affiliated ball there a year after breaking the color barrier for the Brooklyn Dodgers.

McCormick Stadium continues to host the Tourists to this day.

According to various reports, "Minor League segregation in the South ended slowly, beginning in 1951. Also in 1951, the Granite Falls Graniteers in the Class D Western Carolina League signed three black players to become the first team in North Carolina to integrate, though a lack of official statistics from that time make it more difficult to confirm

I THEE WED

People have enjoyed weddings since biblical times. In Western North Carolina, one of the most joyous occasions was a wedding. Created and published in 1874, W.L. Sheppard's wood-engraved caricatures of an African American wedding depicted salient scenes of preparing the wedding garment, going to the feast, the wedding ceremony in the cabin, and the grand ball.

An important part of the bride's role was choosing just the right wedding gown. Custom often dictated that the bride wear her mother's wedding

Woman holding up a wedding dress.

dress. By the 1930s, a bride usually preferred her own style of gown, veil and favorite flowers for her bouquet.

Not all wedding ceremonies, however, were lovely and joyous. The so-called "shotgun wedding" occasionally occurred.

HILLBILLY STEREOTYPE: TITILLATION OR DISASSOCIATION?

How do nonnatives of Appalachia define a "hillbilly?" According to one historian,

> *Common adjectives include slow, dirty, lazy, uneducated, and a dialect sprinkle with poor grammar delivered with a resonant twang. Seldom are mountain residents defined by outsiders as businesspeople, researchers, academics, or professionals. This misconception is not uttered in malice. Rather, it is based on almost a century of exposure to the media's tendency to homogenize southern (and mountain residents) within restrictive stereotypes—those of a hillbilly.*

For many years, in the earliest part of the twentieth century, the only films about Appalachian people were documentaries or news clips that shed a positive light on the lives of mountain people. Settings were usually unspoiled farms, mines or logger camps and presented families working to make a decent living. By the 1920s, Hollywood took over, with movies such as *Sergeant York* and *The Southern Highlands*. Perceptions of mountain people varied in these films, as "some glorified them as hardworking conquerors of the wilderness, an embodiment of the nation's pioneering heritage. Other movies displayed them as the antithesis of progress where moonshine and the environment were fate's determining factors."

Comic strips like *Li'l Abner* also probably fueled negative hillbilly ideas. According to author Milton Ready, "Local natives were Lil'abners [*sic*] and Daisy Maes…big-boned, semi-barbaric people…picturesque with groups of motley, grizzled, and long-haired men in slate-covered home-spun… Primitive mountaineers were everywhere. They added an element of local color to a visit."

Perceptions changed again when Walt Disney's *Davy Crockett* hit the big screen in 1955 and portrayed Davy as a hero. Television producers wrote more documentaries "portraying mountain poverty, bluegrass music, and

Pentecostal snake-handing worship services." Of course, TV shows like *Hee Haw*, *Ma and Pa Kettle* and *The Andy Griffith Show* were down to earth and entertaining; nevertheless, according to one reporter, "some people depicted the people that live in the Southern Appalachians are different from the vast majority of citizens that live throughout the rest of the United States—and those differences are seldom presented as positive."

So, does the hillbilly stereotype cause titillation or disassociation? A historian addresses this question:

> *Though the Appalachian region continues to struggle with a negative stereotype, that image has diminished in recent years. The differences that divide the mountains from the rest of the nation are shrinking as popular culture becomes more homogenized. For more people, fictional depictions of the mountain hillbilly are now just that—fiction. However, it is important that we understand and treasure what makes Appalachia unique—a history and heritage drawn from the landscape and the ability to confront adversity and exchange it for opportunity.*

Titillation or Disassociation? Maybe the question should be revised to include the words "confront adversity and exchange it for opportunity."

THE BELLYACHE HEARD 'ROUND THE WORLD

The Asheville Tourists Baseball Club has hosted Lou Gehrig, Jackie Robinson and Babe Ruth. The bellyache heard "'round the world" originated when Babe Ruth and his Yankee teammates went to Asheville to play an exhibition game against the Brooklyn Dodgers. This is what happened:

> *The Great Bambino had been plagued with fever and horrible stomach cramps throughout the long, mountain spanning trip to Asheville. As Babe Ruth was one of the world's greatest celebrities, it was little wonder that throngs of fans had gathered at the train station to welcome him; little did they know what was about to transpire. In a valiant effort to greet his fans, the afflicted sultan of swat stumbled from the train, took several steps, and promptly collapsed on the hard marble floor. Rumors of his death immediately began to circulate. These rumors quickly reached the international press but were ultimately counted by W.O. McGeehan's now infamous* New York Tribune *story where the incident was referred to as*

"the bellyache heard round the world." Babe Ruth soon returned to New York where he underwent surgery for an intestinal abscess and, after a 7-week recovery, returned to the game.

A year before the bellyache incident, Babe Ruth had stood in right field of McCormick stadium and reportedly exclaimed, "My, my what a beautiful place to play. Delightful. Damned delightful place." The old stadium with it wooden bleachers was torn down in 1991.

May Day: Social or Political Celebration?

May Day celebrations date back to the days before Christ and have a pagan connection. The Druids of the British Isles celebrated on May 1, and their main focus was fire, which they thought would provide life to the springtime sun. The Druids drove their cattle through the fire for purification, and men who had sweethearts walked through the smoke, hoping for good luck with their maidens. For the Romans, their May Day celebration, called the Floralia, lasted for five days.

The Puritans, as might be expected, discouraged May Day celebrations. By the Middle Ages, maypoles appeared in most villages, and often there would be a contest to see who had the tallest. In France, the maypole was known as the Tree of Liberty, symbolic of the French Revolution.

At the earliest part of the nineteenth century, people were working from fourteen to twenty hours a day. The exact tie-in with May Day remains somewhat ambiguous; however, most historical records associate the "sunrise to sunset" work ethic with May Day, perhaps because that was the date when "sunrise to sunset" meant long hours. Nevertheless, the struggle for a shorter workday was associated with May 1. Whatever the connection, demands for a shorter work day increased, and eventually, the eight-hour movement was approved in 1866.

A special May Day festival was held at the Asheville Normal and Collegiate Institute. Women in white dresses held poles with stars at the top. They danced around the maypole. Obviously, their celebration did not symbolize anything political, but it was most likely a tradition established many years earlier when trees were brought into the village square "with a tuft of greenery of some sort left on the end of the pole as a reminder that it was a symbol of the newly awakened spirit of fertility and vegetation." The women possibly associated this awakening with service to the community.

The maypole had colorful ribbons that hung from it. The young women at the institute danced around it, holding the ends of the streamers in such a way that they were woven into a pattern. This Presbyterian college—which emphasized a commitment to service—likely did not have any May Day pagan implications. Research has revealed no symbolic meaning of the stars atop the poles these female students carried; consequently, one can only guess that these represented the "service" mission of the school.

THE LEGEND OF BUCK MOUNTAIN LUTHER

Known only by one name—Luther—he lived on Buck Mountain and claimed to be kin to Daniel Boone. Although he earned his living trading mink, raccoon, bear and deer hides for necessities, such as salt pork, flour, and tobacco, his true talent was his ability to reproduce any bird or animal call. Luther's talent was put to good use when Buck Mountain settlers began to experience wolf raids on their chicken houses. When a bounty was offered for every wolf killed, Luther saw the possibility of earning money. According to legend, this is what transpired:

> *Luther had found wolf tracks up on the mountain and followed them to a small natural cave which was hidden by a fallen tree stump. Inside the den he discovered a litter of eight young wolf pups, alone. Surely the mother and father were nearby, he reasoned. He parted the roots of the stump a bit more for a better look and his heart began to pound furiously at what he saw: Diamonds, dozens of them, were scattered about the floor of the den and he could see even more embedded in the walls of the cave. He picked one up, examined it for a moment in the moonlight, then placed it in his black powder pouch which hung around his neck. As he reached down for more he heard a ghastly bark which became a growl and he suddenly felt his leg being ripped to shreds. He had been found!*
>
> *All at once there were wolves all around him and he flailed frantically at the nearest attackers with the butt of his rifle as he tried to work his way back down the mountain. Just as he was beginning to fear that he was lost, a single wolf made a huge leap, gashing his face and neck, knocking him to the ground. Luther began to slide and roll helplessly down the slope and as he tumbled, the growling and howls began to sound farther away.*
>
> *When he came to a stop several hundred feet later, he realized that the wolves had remained at the den to protect the young. Luther groaned as he*

struggled to his feet and began to make his way to a solitary cabin down in the valley where a settler found him at his door. Luther was dying, but he opened his eyes which glistened in the moonlight and told the settler what had happened. Luther died the same night and was buried in an unmarked grave behind the hen house.

Remarkably, Luther had held on to his rifle, which the settler kept along with the powder pouch. When he went to town and traded a fine uncut diamond for supplies, livestock, and corn whiskey, the alcohol loosened his tongue and he exposed Luther's valuable find.

The locals of Buck Mountain, who looked outside on moonlit nights, claim they saw a human shadow, with the unmistakably gait of Luther, roaming as he searched for the lost wolf den and uncut diamonds.

Mountain Recipes

WILTED LETTUCE

1 tbs. bacon drippings (No substitute.)
1 tbs. flour
3 tbs. sugar
¾ cup water
1 tsp. salt
1 egg
¼ cup vinegar
Garden lettuce
Spring onions
¼ cup bacon bits

Mix first seven ingredients thoroughly and boil for 2 to 3 minutes. Pour over a mess of fresh garden lettuce and toss with a bunch of spring onions, sliced, and the bacon bits. Serve immediately and eat all of it because leftovers are soggy.

PUMPKIN POUND CAKE

2 cups sugar
4 eggs
1 cup oil
2 cups flour

$^1/_2$ tsp. salt
2 tsp. cinnamon
2 tsp. baking soda
2 cups pumpkin, mashed
 Mix sugar and eggs in a large bowl. Add oil and mix well. Mix dry ingredients and add to bowl. Add pumpkin and blend at slower speed of mixer until well blended. Pour into greased and floured tube pan and bake one hour in a 350-degree oven.

Icing:
1 8-oz. package cream cheese
1 stick soft butter
2 tsp. vanilla
1 lb. box powdered sugar
 Blend until smooth and ice cake.

CREAMY MACARONI 'N CHEESE

8 oz. boiled macaroni
2 tbs. butter
1$^1/_4$ cups sharp cheese (cut into cubes)
$^3/_4$ tsp. salt
$^1/_4$ tsp. pepper
2 cups milk
Dash paprika
 Alternate layers consisted of the above in baking dish. Bake 40 minutes in a 350-degree oven.

CHERRY CRUNCH

Buttered oblong baking dish
1 can cherry pie filling
1 large can crushed pineapple
1 package yellow cake mix
2 sticks butter
1 cup chopped nuts

Mix together pie filling with crushed pineapple. Sprinkle cake mix on top. Dot with butter and sprinkle nuts over mixture. Bake 1½ hours at 350 degrees.

Sorghum Peanut Butter Cookies

1½ cups creamy peanut butter
1 cup butter-flavor Crisco shortening
2½ cups firmly packed light brown sugar
6 tbs. milk
2 tsp. vanilla
2 eggs
3 cups sorghum flour*
½ cup chickpea flour (garbanzo)*
½ cup sweet rice flour*
4 tsp. xanthan gum
1 tsp. salt
1½ tsp. baking soda

Heat oven to 375 degrees. Combine peanut butter, shortening, brown sugar, milk and vanilla in large bowl. Beat at medium speed of electric mixer until well blended. Add eggs. Beat just until blended. Combine flour, xanthan gum, salt and baking soda. Add to creamed mixture at low speed. Mix until blended.

Using a mini ice cream scoop, drop balls of dough 2 inches apart on baking sheet lined with parchment paper. Flatten slightly in a crisscross pattern with tines of fork. Bake 8 to 10 minutes, or until set and just beginning to brown. Cool 2 minutes on baking sheet. Remove cookies from pan to cool completely. Makes about 6 dozen cookies.

*available at health food stores

Cornbread Dressing

1 cup chicken fat
2 cups onion, chopped
1 cup fresh mushrooms
2 cups celery, chopped
12 squares cornbread, crumbled

12 soda crackers, crumbled
1 cup parsley, minced
1 tbs. fresh rosemary, minced
1 tbs. fresh thyme, minced
Salt
2 eggs
Chicken stock

In chicken fat, sauté onion until limp. Remove to large mixing bowl. In remaining chicken fat, sauté mushrooms and celery until tender. Mix with onion. Add other ingredients: cornbread, crackers, parsley, rosemary, thyme and salt. Add eggs, mix and put into a baking dish 2 inches deep. Sprinkle with a little chicken stock. Serve with a bowl of gravy.

SISTER ANN'S CORN BREAD

1 14¾-oz. can creamed corn
1 16-oz. carton sour cream
½ cup oil
4 eggs, beaten
1 onion, chopped
¾ lbs. sharp cheese (about ¾ cup grated)
1 4-oz. can jalapeno peppers
1 cup yellow cornmeal
1 tbs. baking powder
1 cup flour
1 tsp. salt

Stir corn, sour cream and oil together. Add eggs. Fold in onion, cheese and jalapeno peppers. Add cornmeal, baking powder, flour and salt, and mix well. Bake in 9x13-inch greased pan at 350 degrees for 55 to 60 minutes.

PORK DELIGHT

¼ cup soy sauce
1 tbs. grated onion
1 tbs. vinegar
1 clove garlic, mashed
¼ tsp. red pepper

$\frac{1}{2}$ tsp. sugar
2 pork tenderloins
2 slices bacon
$\frac{1}{3}$ cup sour cream
$\frac{1}{3}$ cup mayonnaise
1 tbs. hot dry mustard
1 tbs. chopped green onion
$1\frac{1}{2}$ tsp. vinegar
Salt and pepper to taste.

Mix first six ingredients and pour over pork. Let stand overnight, piercing meat and turning several times. Remove meat, top each with a slice of bacon and place in an uncovered baking pan. Bake $1\frac{1}{2}$ hours in a 300-degree oven, basting with reserved marinade. Mix remaining ingredients for sauce to serve with pork.

MIGHTY FINE FRUITCAKE

2 sticks butter
1 box light brown sugar
2 cups granulated sugar
9 eggs, beaten
1 small can crushed pineapple (mashed)
4 cups self-rising flour
1 orange (peeled and chopped)
3 apples (chopped)
4 bananas (mashed)
1 box white raisins
1 small box dates (chopped)
2 lbs. Mixed (chopped) fruit (candied cherries and pineapple)
1 small coconut (ground or grated)
4 cups pecans
1 tsp. cinnamon
1 tsp. nutmeg
1 tsp. vanilla extract

Cream butter and brown and white sugar. Add eggs and crushed pineapple. Then add flour (save enough flour to dredge fruit) and spices. Mix well and add all other fruits and nuts. Mix well. Bake in tube pans at 300 degrees until done—approximately 3 hours. (This makes 2 cakes.) Because of the bananas, the finished cakes should be refrigerated. Delicious.

REFRIGERATOR SLAW

1 cup vinegar
1 cup sugar
¼ cup water
1 tbs. mustard seed
1 tbs. salt
1½ quarts shredded mountain cabbage
3 bell peppers, shredded
2 onions, shredded
1 carrot, shredded

Boil vinegar, sugar, water, mustard seed and salt. Let cool. Pour over shredded veggies and refrigerate overnight.

APPLE DUMPLINGS

6 apples, peeled and cored
2 cups flour
½ tsp. salt
⅔ cup shortening
5–6 tbs. ice water
1 cup sugar
2 cups water
3 tbs. butter
¼ tsp. cinnamon
Red food coloring
1 cup sugar
1½ tsp. cinnamon
Butter

Cook apples until tender. Make pastry by combining flour, salt, shortening and ice water. Roll out and cut in circles the size of a coffee saucer.

For the syrup, mix together sugar, water, butter, cinnamon and enough red food coloring to make mixture bright red. Boil for three minutes.

Now, place cooked apples over half of each separate circle. Sprinkle with a mixture of sugar and cinnamon (divide evenly between circles). Fold each part of the circle without apples over the apples and crimp edges with fork dipped in ice water. Grease baking dish and place each half circle in baking dish. Dot with butter. Pour hot syrup over all and bake at 400 degrees for 40 to 45 minutes.

Corn Pudding

1 cup fresh corn
1 egg, well beaten
¼ cup flour
¼ tsp. salt
¼ tsp. pepper
4 tbs. real butter
2 tbs. sugar (optional)
Mix all ingredients, pour into a buttered 1½ quart casserole. Place the casserole dish in a pan of hot water. Bake until firm at 350 degrees.

Cranberries and Apples

3 cups apples, peeled and chopped
2 cups fresh cranberries
2 cups sugar
½ cup oatmeal
½ cup brown sugar
1 stick butter
$\frac{1}{3}$ cup flour
½ cup chopped pecans

Mix apples and cranberries and place in a buttered casserole. Pour sugar on top. Mix remaining ingredients, except nuts. Top with nuts and bake in a 350-degree oven for 1 hour.

German Cole Slaw

¾ cup chopped bacon
2 tbs. lemon juice
½ tsp. salt
½ cup mayonnaise
2 cups grated cabbage
4 tbs. green pepper
2 tbs. parsley
1 tbs. onion

Place chopped bacon in frying pan and cook to a golden color. When browned, add lemon juice and salt. Stir well and mix with mayonnaise. Combine vegetables and dressing. Makes 4 servings.

Pinto Beans and Ham Hocks

3 smoked ham hocks
$\frac{1}{2}$ tsp. garlic powder
$\frac{1}{2}$ tsp. crushed red pepper
$\frac{1}{4}$ tsp. ground black pepper
$\frac{1}{2}$ tsp. salt
2 lbs. dried pinto beans
2 tsp. hot sauce
$\frac{1}{2}$ medium chopped onion
Cooked rice

Boil ham hocks on high heat for 45 minutes. Add all seasonings except beans, hot sauce and onion. Continue boiling for 20 minutes. Add pinto beans, hot sauce and onion. Boil on medium heat until beans are done to taste.

Note: To speed up cooking of beans and reduce the gas that beans produce, soak beans in cold water overnight or for three hours during the day.

Serve with rice.

Divinity

3 cups sugar
$\frac{1}{2}$ cup white Karo syrup
$\frac{1}{3}$ cup hot water
2 egg whites
1 tsp. vanilla
1 cup walnuts

Combine sugar, Karo syrup and water in heavy saucepan. Cook slowly to soft ball stage. Add to beaten egg whites, one tablespoon at a time, until half of syrup is used. Cook remaining syrup to firm ball stage. Add to already prepared egg white mixture. Beat until mixture loses its glossiness. Add vanilla and nuts. Drop onto waxed paper to cool. Store in refrigerator or cool place.

Note: You probably should double recipe for thermometer to fit in pot.

Sweet Potato Biscuits

2 cups all-purpose flour
$^2/_3$ cup sugar
2 tbs. baking powder
$^1/_2$ tsp. salt
$^1/_2$ cup butter Crisco
2 cups cooked mashed sweet potatoes
$^1/_4$ cup milk

Sift flour, sugar, baking powder and salt. Cut in Crisco. Mix in sweet potatoes. Add milk gradually to make a soft dough. Turn out on lightly floured board. Knead lightly. Roll to $^1/_2$ inch thickness. Cut with biscuit cutter. Bake on greased cookie sheet 12 to 15 minutes at 450 degrees.

Mrs. Johnson's Liver Mush

1 pork liver
Pork fat
Cornmeal

Boil a pork liver and a small amount of pork fat in clear water until tender. Cool liver. Save the stock. Put liver through meat grinder. Add an amount of cornmeal equal to (or a little more) than the liver. Skim fat off top of stock and add it to a small amount of clear water; bring to a boil. Add pinch of cornmeal and cook for some time. Liver mush should be thin enough to spread itself when poured into a pan. Cool. Spread lard over top of edges to keep liver mush from drying out.

Cheesy Broccoli Soup

2 tbs. butter or margarine
$^1/_4$ cup chopped onion
2 tbs. flour
$2^1/_2$ cups milk
$^3/_4$ cup prepared cheese product, cut up (Velveeta works fine.)
1 package (10 oz.) frozen chopped broccoli, thawed, drained
$^1/_8$ tsp. pepper

Melt butter in large saucepan on medium heat. Add onion; cook and stir 5 minutes or until onion is tender. Add flour; cook 1 minute or until bubbly, stirring constantly. Stir in milk. Bring to boil. Reduce heat to medium-low; simmer 1 minute. Add remaining ingredients. Cook until cheese is melted and soup is heated through, stirring occasionally.

BLACK-EYED PEA SALAD

2 cans black-eyed peas, rinsed and drained
1/2 cup red onion slices
1/2 cup green pepper, chopped
1 small garlic clove, minced
1/4 cup vinegar
1/2 tsp. salt
Pepper to taste
Dash hot pepper sauce
 Combine peas, onion and pepper. Stir together other ingredients and toss with pea mixture. Cover and refrigerate at least 12 hours.

SWEET POTATO CASSEROLE

3 or 4 medium-sized sweet potatoes, cook and mashed
1/2 stick butter, melted
1 cup brown sugar
1/2 teaspoon salt
1 teaspoon vanilla
1 cup flaked coconut
1/2 cup chopped pecans
1 small can crushed pineapple with juice
Regular-sized marshmallows, enough to cover casserole (optional)
 Mix all and put into a casserole. Bake at 350 degrees for 30 to 35 minutes. Top with marshmallows, if desired, and broil briefly until golden.

CHICKEN SALAD

2½ to 3 lbs. boneless, skinless chicken breasts, cooked and cup up in chunks
1 8-oz. can water chestnuts, sliced
1 lbs. seedless grapes (use whole)
2 cups chopped celery
2–3 cups slivered almonds (toasted). Save ½ cup for top
1 cup mayonnaise
1 tsp. curry powder
1 tsp. soy sauce
1 tbs. lemon juice.
Lettuce of choice
1 can (20 oz.) pineapple chunks

Combine first five ingredients. Combine next four ingredients and toss gently. Spoon onto beds of lettuce on individual plates. Sprinkle with pineapple and leftover almonds.

CHESS PIE

½ stick real butter
2 cups brown sugar
1 tbs. flour
1 tbs. sweet milk
Pinch of salt
1 tsp. vanilla
2 eggs

Melt butter; add to sugar. Add flour and milk, salt and vanilla. Add whole eggs. Beat. Pour into 9-inch pie pan lined with unbaked pastry. Bake very slowly, about 325 degrees, for about 30 minutes.

PECAN PIE

¼ cup butter, melted
¾ cup brown sugar
4 eggs
1–2 tbs. bourbon
½ cup light corn syrup

¾ tsp. salt
1½ cups pecans, chopped
1 pie shell
Freshly whipped cream

Combine butter and sugar; add eggs, bourbon, corn syrup, salt and pecans. Pour into pie shell and bake 45 minutes at 375 degrees. Serve with whipped cream.

CORNMEAL GRIDDLE CAKES

1 cup cornmeal
1 cup all-purpose flour
1 tsp. salt
4 teaspoons baking powder
1 egg, well beaten
2½ cups milk
¼ cup shortening, melted

Mix dry ingredients. Combine egg and milk and stir in dry ingredients. Stir the shortening and add more milk if necessary to make a thick batter. Fry on a hot greased griddle.

Bibliography

"Abraham Lincoln's Birth." Carolina Country, http://www.carolinacountry.com.

"Appalachian League." Wikipedia.org, http://en.wikipedia.org/wiki/Appalachian_League.

Arthur, John Preston. *History of Western North Carolina, 1914.* Raleigh, NC: Edwards & Broughton Printing Company, 1914.

"Asheville and Buncombe County." Internet Archive, http://www.archive.org/stream/ashevillebuncomb00sond/ashevillebuncomb00sond_djvu.txt.

"Asheville Female School." Wikipedia.org., http://en.wikipedia.org/wiki/Asheville_Female_College.

"Asheville History Ranges from Early Settlements to Downtown Skyscraper." Romantic Asheville.com, http://www.romanticasheville.com/History.htm.

"Asheville Normal School." Western North Carolina Heritage, http://www.heritagewnc.org/WNC.

"Asheville, North Carolina: A National Register of Historic Places." U.S. National Park Service, http://www.nps.gov/history/nr/travel/asheville/text.htm.

Avery, Clifton K., ed. "Official Court Record of the Trial, Conviction and Execution of Francis Silvers." *(Morganton, NC) News-Herald*, 1969.

Ballew, Bill. *Baseball in Asheville.* Charleston, SC: Arcadia Publishing, 2004.

"The Beautiful Sapphire Country." D.H. Ramsey Library, Special Collections, University of North Carolina–Asheville, 1901.

"Big Tom: Legend and Reality." North Carolina Travel Guide, http://www.northcarolinaguide.net/big-tom-legend-and -reality/.

"Big Tom Wilson Dead at 85." *New York Times*, February 6, 1908.

"Biltmore Estate." U.S. National Park Service, http:www.nps.gov/history/nr/travel/Asheville/text.htm.

"Biltmore Estate: A Legacy in Stone." Blue Ridge Highlander.com, http://www.theblueridgehighlander.com.

"The Biltmore Estates in Asheville, North Carolina Recreates the 'Wedding of the Decade.'" Hudson Valley Weddings.com, http://www.hudsonvalleyweddings.com/guide/biltmore.htm.

"The Blackwell Memorial on the Asheville Urban Trail, Asheville, N.C." Hobart and William Smith Colleges, http://campus.hws.edu/his/blackwell/urbantrail.html.

"Brown Mountain Lights." Brown Mountain Lights.com, http://shadowboxent.brinkster.net/brownhistory.html.

Carlin, Bob. "The Life and Music of Fiddlin' Bill Hensley." *Old Time Herald* 11, no. 4.

———. "Whip the Devil 'Round the Stump: More Stories from the Helton Brothers." *Old-Time Herald* 10, no. 10.

"Cataloochee: A Valley and Its History." Cataloochee, http://cataloochee-nc.tripod.com/end.htm.

"Cataloochee Today." Cataloochee, http://cataloochee-nc.tripod.com/today.htm.

"CCC Brief History." Civilian Conservation Corps Legacy, http://www.ccclegacy.org/CCC_brief_history.htm.

"Chestnut Hill Historic District." U.S. National Park Service, http://www.nps.gov/istory/NR/travel/Asheville/che.htm.

Child Labor in the Carolinas. [A]ccount of Investigations Made in the Cotton Mills of North and South Carolina, by Rev. A. E. Seddon, A. H. Ulm and Lewis W. Hine, Under the Direction of the Southern Office of the National Child Labor Committee. KcKelway, Alexander Jeffrey, 1866-1918. New York: National Child Labor Committee, 1909.

"City of Morganton: Local History." City of Morganton, http://www.ci.morganton.nc.us.

"Connemara-Carl Sandburg Home-Paula Sandburg's Office." Flickr, http://www.flickr.com.

"Corn Meal Griddle Cakes." The Blue Ridge Parkway Foundation, http://www.blueridgeparkwaystore.com.

"Dr. Carl Von Ruck Dies in Asheville: Noted Specialist Who Discovered a Vaccine for the Prevention and Cure of Tuberculosis." *New York Times*, November 7, 1922.

"Dr. Mary Frances (Polly) Shuford." Oral History Register. D.H. Ramsey Library Special Collections, University of North Carolina–Asheville.

Ebel, Julia. Interview and e-mail correspondence, September 8, 2010, July 4, 2010 and November 19, 2010.

Egender, Herb. "A Brief History of Square and Round Dancing." Dosado. com, http://www.dosado.com/articles/hist-sd.html.

"Elizabeth Blackwell." Wikipedia.org, http://en.wikipedia.org/wiki/Elizabeth_Blackwell.

————. Hobart and William Smith Colleges, http://campus.hws.edu/his/blackwell/articles/investors.html.

"Elizabeth Blackwell, Physician." Answers.com, http://www.answers.com/topic/elizabeth-blackwell.

Ellison, George. "Bit Tom Wilson Was Legendary Mountain Man." *Smoky Mountain News*, May 22, 2002.

"The End of Cataloochee, 1866 to 1930." Cataloochee, http://cataloochee-nc.tripod.com/end.htm.

"Fields of the Wood: The World's Largest Ten Commandments." Western NC Attractions, http://www.westernncattractions.com/fieldsof.htm.

"Frank Proffitt." Wikipedia.org, http://en.wikipedia.org.

"Golden Valley Ghosts." Hub Pages, http://hubpages.com.

"Hendersonville's Past." Hendersonville Historic Preservation Commission, http://www.hendersonvillehpc.org/hendersonville.

"The Historic Hot Springs, North Carolina: History." The Historic Hot Springs, North Carolina, http://www.hotspringsnc.org/history.php.

"History of Baseball in the United State." Wikipedia.org, http://en.wikipedia.org/wiki/History_of_baseball_in_the_United_States.

"Hot Springs, North Carolina." Wikipedia.org, http://en.wikipedia.org/wiki/Hot_Springs,_North_Carolina.

Jamison, Phil. "The Dance Beat/Issues in Old Time Music: Community Dances in the Eighties: Dare to be Square." *Old-Time Herald* 1, no. 6 (Winter 1988–89).

"Kenilworth Inn Is Destroyed by Fire." *Grand Forks (ND) Daily Herald*, April 15, 1909.

"The Kingston Trio Lyrics—Tom Dooley." Oldie Lyrics, http://www.oldielyrics.com/lyrics.

"The Legend of Tom Dooley." Educational CyberPlayground, http://www.edu-cyberpg.com/music/folk_Tom_Dooley.html.

Lewis, Jane Johnson. "Elizabeth Blackwell: First Woman Physician." About.com, http://womenshistory.about.com/od/blackwellelizabeth/a/eliz_blackwell.htm.

"Little Switzerland, North Carolina." Wikipedia.org, http://en.wikipedia.org/wiki/Little_Switzerland,_North_Carolina.

"Log Cabin Architecture, History and Styles," http://logcabinarchitecture.jeannieland.com.

"Log Cabins." City of Rochester Hills, Michigan, http://www.rochesterhills.org/city_services/museum/history/log_cabins.asp.

Mary Chiltoskey. Audiotape of a Western North Carolina Historical Association meeting, Cherokee, North Carolina, April 1972. Recorded by Dr. Louis D. Silveri.

Mayo, Jonathan. "Integration of the Minor League South." Minor League Baseball, http://www.minorleaguebaseball.com.

McCall, K.D. "The Cherry Mountain Fiasco." Golden Valley, NC, http://www.goldenvalleync.com/cmf.html.

"McCormick Field/Asheville Tourists." Ballpark Digest, http://www.ballparkdigest.com/visits/index.html.

"Milestones, Apr. 9, 1934." Time.com, http://www.time.com/time/magazine/article/0,9171,929738,00.html.

"M'Kinley Visits Biltmore Refuses to Enter George Vanderbilt's House." *New York Times,* June 15, 1897.

"Monford Area Historic District." U.S. National Park Service, http://www.nps.gov/history/NR/travel/Asheville/mon.htm.

Motsinger, Carol. "Asheville a Destination for Many Presidents." *Asheville Citizen-Times.*

Myers, Hannah Rice. "About Whittling." eHow, http://www.ehow.com/about_4596098_whittling.html.

"The Mystery of Nancy Hanks Calhoun, Lincoln: Enigma Still Intrigues Historians." GreenvilleSouth.com, http://www.greenvillesouth.com/abe.html.

"The Normal and Collegiate Institute, Asheville." D.H. Ramsey Library, http://toto.lib.unca.edu/WNC.

"North Carolina Poorhouse History." The Poorhouse Story, http:www.poorhousestory.com/poorhouses_in_north_carolina.htm.

"Noted Specialist Who Discovered a Vaccine for the Prevention and Care of Tuberculosis." *New York Times,* November 7, 1922.

"OB Wright House—Asheville, North Carolina." U.S. National Park Service, http://www.nps.gov/history/NR/travel/Asheville/obw.htm.

Palmer, Pamela. "Denizens of Biltmore." *Book Think* 72 (July 10, 2006).

Patterson, Daniel W. *The Tree Accurst: Bobby McMillon and Stories of Frankie Silver.* Chapel Hill: University of North Carolina Press, 2000.

"Paupers in Almshouses, 1904." *Summary of Poor Laws by State.* Washington, D.C.: Government Printing Office, 1906.

Pennell, Steven W., Joshua B. Livesey and Professor Hugh D. Hindman. "Child Labor in North Carolina Cotton Mills: 1908–The Beginning of the End." Appalachian State University, Boone, North Carolina.

"Pinto Beans and Ham Hocks." Chitterlings: The Soul Food Site, http://www.chitterlings.com/pinto.html.

"President Abraham Lincoln Birthplace Cover Up." HubPages, http://hubpages.com.

"Sapphire-Welcome to 'Little Switzerland.'" NC Mountain Life, http://www.ncmountainlife.com/about-sapphire.php.

"Sherrill's Inn." U.S. National Park Service, http://www.nps.gov/history/nr/travel/asheville/she.htm.

———. U.S. National Park Service, http://www.nps.gov/history/NR/travel/Asheville/text.htm.

Sink, Alice E., and Nickie Doyal. *Boarding House Reach: North Carolina's Entrepreneurial Women.* Wilmington, NC: Dram Tree Books, 2007.

"Southern Cooking Recipes." The Blue Ridge Parkway Foundation, http://www.blueridgeparkwaystore.com/cats/1870_southern-cooking-recipes.asp.

Styles, Harriet, and Bill Alexander. "Swannanoa: Then and Now: A Brief History of Swannanoa," http://swannanoathenandnow.blogspot.com/2009/05/brief-history-of-swannanoa.html.

"Tom Dula." DocStoc.com, http://www.docstoc.com/docs/6375159/Tom_Dula.

Toxaway Company. "The Beautiful Sapphire Country." Special Collections/University Archives. D.H. Ramsey Library, University of North Carolina–Asheville.

"Trout Cooking Recipes." NC State University, http://haywood.ces.ncsu.edu/content/TroutCookingRecipes&source=haywood.

Undated, handwritten six-page letter written by "Everette" to "Ella." Property of the author.

"Visit Blue Ridge Parkway: Doughton Park." Visit Blue Ridge Parkway, http://visitblueridgeparkway.com/doughtonpark.php.

"Von Ruck House." U.S. National Park Service, http://www.nps.gov/history/NR/travel/Asheville/von.htm.

"Warren Wilson College." The Princeton Review, http://www.princetonreview.com/WarrenWilsonCollege.aspx.

"Whittling," eHow.com, http://www.ehow.com/about_4596098_whittling.html.

"Wildflowers: Hiking Trails of the Southern Appalachians." Inspirezone.org, http://inspirezone.org/wildflowers22.html.

Young, Perry Deane. *The Untold Story of Frankie Silver: Was She Unjustly Hanged?* Asheboro, N.C.: Down Home Press, 1998.

About the Author

Alice E. Sink is a retired associate professor of English at High Point University. She holds a master's of fine arts in creative writing and a bachelor of arts degree in English, both from the University of North Carolina at Greensboro. She is the recipient of the 2002 Meredith Clark Slane Distinguished Teacher-Service Award. In addition to this, her tenth book, she has been published in a large number of magazines including *Now and Then: The Appalachian Magazine*, *St. Andrew's Review*, *Piedmont Pedlar*, *Jack and Jill*, *South Carolina Review*, *Our State Magazine*, *Carolina Country* and various other media across the United States. She is the former presenter of the North Carolina Humanities Council and a former winner of the North Carolina Writers and Reader Series. She is a North Carolina Arts Grant recipient, and her biography has been published in the North Carolina Literary Review. She has two grown children and five grandchildren and lives with her husband, Tom, in Kernersville, North Carolina.

Visit us at
www.historypress.net

www.ingramcontent.com/pod-product-compliance
Lightning Source LLC
Chambersburg PA
CBHW070343100426
42812CB00005B/1404